Capture the
Charm *of* Your Hometown *in* Watercolor

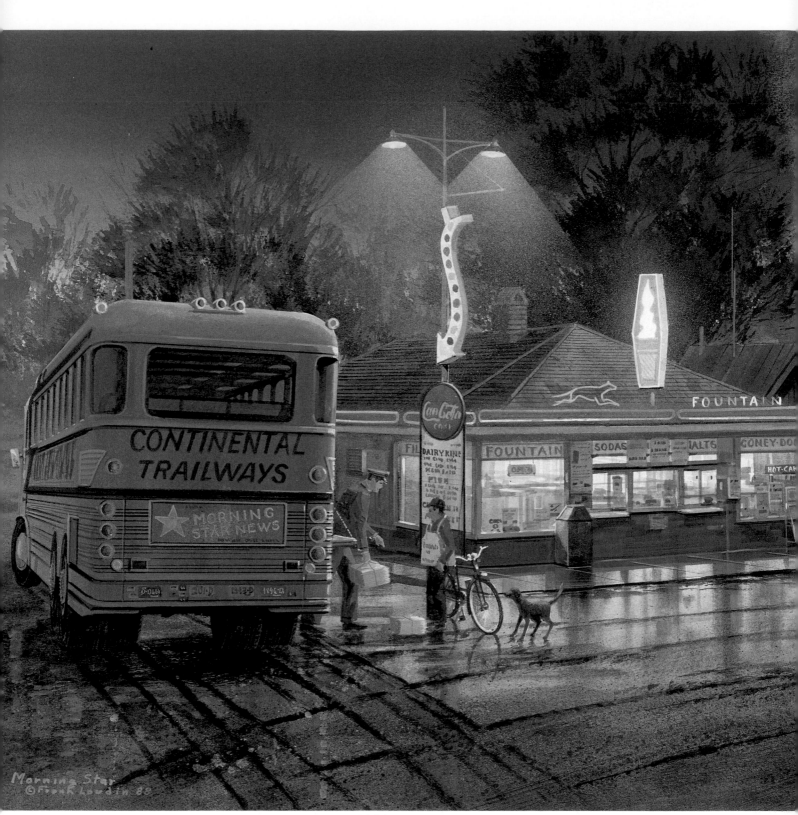

MORNING STAR
14"×22" (35.6cm×55.9cm)

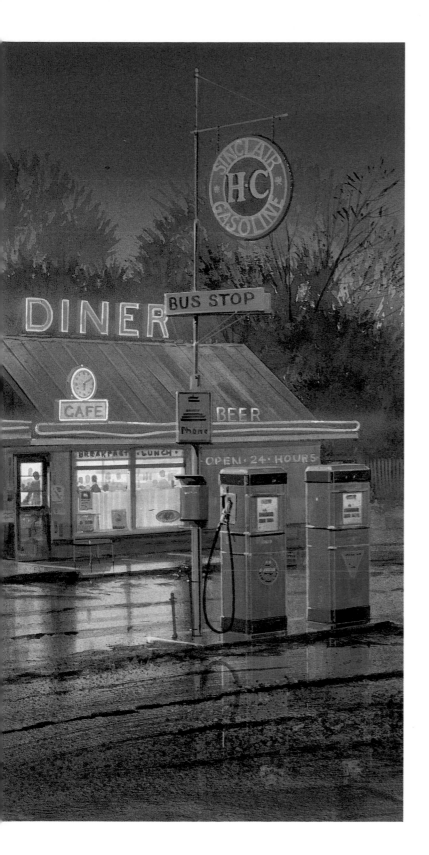

Capture the
Charm of Your
Hometown
in Watercolor

Frank Loudin
With Marcia Spees

NORTH LIGHT BOOKS
CINCINNATI, OHIO

ABOUT THE AUTHOR

The son of a Methodist minister, Frank Loudin experienced a nomadic childhood as his family relocated often throughout West Virginia and New Mexico. Traces of that lifestyle remain today as Frank, his wife, Jan, and their dogs, Raven and Teezer, crisscross backroads and investigate small-town America with camera in hand, searching for inspiration for his "story illustrations."

Frank received a B.F.A. from the University of Colorado in 1952 and enlisted in the Marine Corps, serving as an artillery officer during the Korean War. He attended the Art Center School in Pasadena and worked in architectural illustration in the Los Angeles area for over thirty years. He is highly respected in that field and particularly known for his birds-eye views of harbor facilities around the world.

He has developed a following as an illustrative artist, specializing in aviation history, marine art, vintage automobiles and trains, architecture and backroads Americana. His work graces the Posty Cards greeting card line, and his aviation and Americana prints are distributed nationwide by Advertising Unlimited and Sportsman's Market, among others.

The Loudins owned and operated the Frank Loudin Gallery on Catalina Island for several years. And he has been a longtime exhibitor at the Peppertree Art Show in California.

Frank and Jan make their home on an island in Washington State where the surrounding natural beauty has inspired Frank's artistic eye to envision miniature magic in cedar stumps and waterfalls . . . but that's another book.

For more information about Frank's work, or a listing of available prints, contact:
Frank Loudin Studio
Enchanted Forest Road
P.O. Box 1017
Eastsound, WA 98245
Phone: (360) 376-5642
Fax: (360) 376-3274

Capture the Charm of Your Hometown in Watercolor. Copyright © 1998 by Frank Loudin. Manufactured in Singapore. All rights reserved. No part of this book may be reproduced in any form or by any electronic or mechanical means including information storage and retrieval systems without permission in writing from the publisher, except by a reviewer, who may quote brief passages in a review. Published by North Light Books, an imprint of F&W Publications, Inc., 1507 Dana Avenue, Cincinnati, Ohio 45207. (800) 289-0963. First edition.

Other fine North Light Books are available from your local bookstore or direct from the publisher.

02 01 00 99 98 5 4 3 2 1

Library of Congress Cataloging-in-Publication Data

Loudin Frank.
 Capture the charm of your hometown in watercolor / by Frank Loudin, with Marcia Spees.
 p. cm.
 Includes index.
 ISBN 0-89134-792-5 (alk. paper)
 1. Watercolor painting—Technique. 2. Cities and towns in art. 3. Buildings in art. I. Spees, Marcia. II. Title.
ND2350.L68 1998
751.42′244—dc21
 97-31260
 CIP

Edited by Joyce Dolan
Production edited by Marilyn Daiker
Interior designed by Sandy Conopeotis Kent
Cover designed by Angela Lennert Wilcox
Cover illustrations by Frank Loudin

The art of Elizabeth Apgar-Smith and Gary Simmons reproduced in this book is used by permission of the artist.

ACKNOWLEDGMENTS

My dad, who taught me the value of patience and a good story, and my mom, who nurtured me and saw to my education.

My family and friends, who have enjoyed the unfolding of my career.

Jim Avery, my professor at the University of Colorado, who whetted my appetite for commercial art.

Maurice Harvey, my artistic role model.

Les "somebody," an employment agency guy who practically forced me into my first art job.

The Catalina Art Festival, which boosted my ego with much recognition.

Irma Eubanks, who picked me out of a crowd and taught me about art shows.

The creative community on Orcas Island, which continually inspires me, especially Marri Parkinson, who encouraged me to discover a new magic in fantasy art.

My friend, Jan Kunz, who introduced me to Rachel Wolf and this book idea.

The talented professionals at North Light—Marilyn Daiker, Sandy Kent and Angela Wilcox—especially Joyce Dolan, who kindly shepherded me through the convolutions of making a book.

Marcia Spees, my dear friend and talented wordsmith, who can read my mind and arrange my thoughts into English.

My wife and soul mate, Jan, with whom I have traveled this chosen path supported by her love, understanding, encouragement and humor. She is truly the wind beneath my wings.

DEDICATION

To all those people out there who are convinced that their hometown is *the* place to live. Whether they are aware of it or not, the everyday parts of their lives are the romance of Americana; the back porch they plan to paint; the yard they mean to mow; the old pickup they intend to restore; their dogs and cats; the gatherings at the coffee shop, church rummage sale or parade; spring, summer, autumn and winter. It's everything that symbolizes their place and existence as time comes out of the morning mist and strolls along familiar streets, then leaves town on the evening bus with a suitcase full of snapshots to remember them by.

BREATH OF SPRING, *12″×18″ (30.5cm×45.7cm)*

Table of Contents

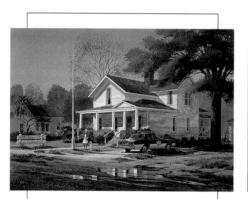

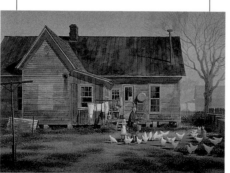

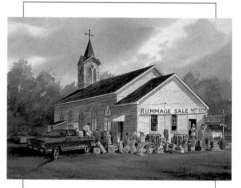

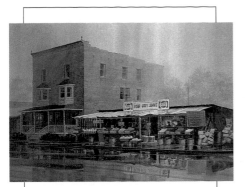
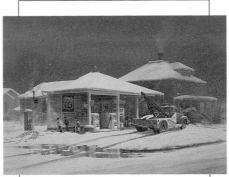

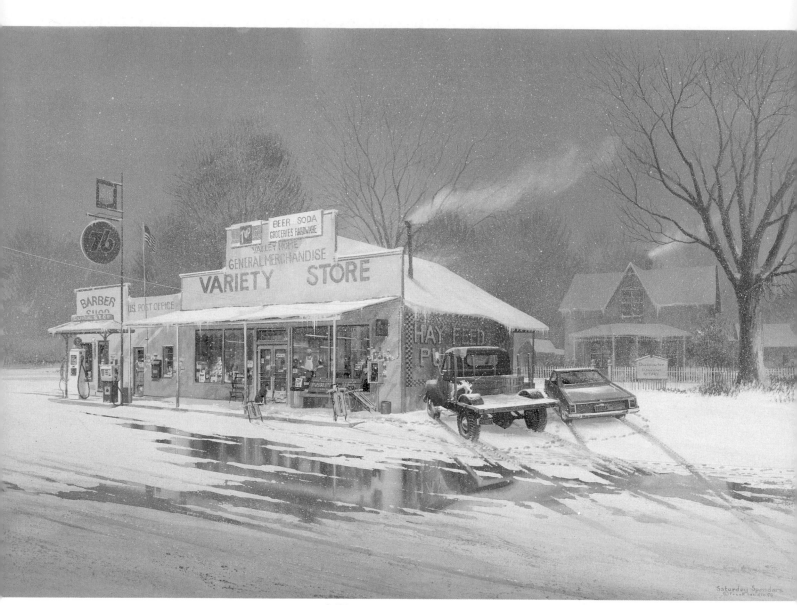

SATURDAY SPENDERS
18"×26" (45.7cm×66cm)

"*Spending a bit of a snowy Saturday at the store seemed to foster friendships whether one lingered for a spell over a pop or just stopped in for a quick necessity.*"

Introduction

Paint a Story

Every town has stories just waiting to be told. You can find them in familiar landmarks, buildings, people and scenes. I want this book to inspire you to observe your everyday neighborhood and draw from its character, creating paintings filled with beauty, tender appreciation and touches of humor.

I went to art school to become a story illustrator back in the times when magazines were full of double-page, full-color illustrations. My heroes were Norman Rockwell, Al Parker, Steven Dohanos, John Clymer, Auston Briggs, Robert Fawcett and others who did weekly illustrations for major magazines.

When I finished art school, most of those magazines had disappeared from the newsstands due to the rise of movies and television. So I became an architectural delineator, but I still wanted to tell stories with my paintings.

As my career changed from commercial illustration to what I call *gallery paintings*, I realized I was drawn to subjects that suggested self-contained, cogent little stories. I began to embellish further in that direction with pertinent titles and even short written paragraphs to enhance the story line in each painting. I'm now proud to call my work illustrations because to me, the story is as important as the painting itself.

I begin a painting by making up a story suggested by my subject matter, which is often a structure, an old car,

an airplane or even an odd-shaped tree with some quirky appeal or characteristic. I usually combine images drawn from a variety of sources. If you're not in the habit of collecting images and references with your camera or sketchbook, begin now. Become a collector. Look around.

I love to collect images of old signs, license plates, piles of hubcaps, gas station pumps, old trucks and cars, heaps of junk. Perhaps you're more into garden furniture or kids' lunch boxes. What's important is that these recognizable elements, when combined into a painting, strike a chord of familiarity in the mind of the viewer.

Before I even think of picking up a brush, I work up several drawings on tracing paper, using overlays to shift elements around. If I have a good basic composition on a slide, I use a table mounted slide projector to facilitate drawings. When I start to paint, I've usually done five or so drawings including a perspective drawing.

I pay particular attention to perspective and scale. Sharp architectural corners are important, and I use mechanical means—including rulers, ellipse guides, bridges and French curves—for precise lines and edges.

When I'm satisfied with my final drawing, I trace it onto watercolor board. By the time I'm ready to stir my paints, I know the exact story I want to tell.

Spark of Life
Always be on the lookout for the contradictory surprise, the unexpected detail that can inject the spark of life into a painting and draw the viewer closer.

Begin With a Sketch

Ideas for story illustrations of your hometown are everywhere. These four reference photos of houses from different parts of the country could inspire any number of story lines.

Make a thumbnail sketch of your subject to set up the lights and darks, simplify the lines and elements and establish a composition. Some artists like to make sketches and color studies on location. I use my camera to collect lots of photos, then make quick composition sketches from color slides.

Even in these early sketches, I use a straightedge to keep the architectural lines true. While I'm sketching, I think about various stories suggested by the subject.

Imagine a Story
I was attracted to the southern flavor of this house in Missouri. Its thick background foliage and the swings in the foreground suggest the possibility of children at play. Hide-and-seek, anyone?

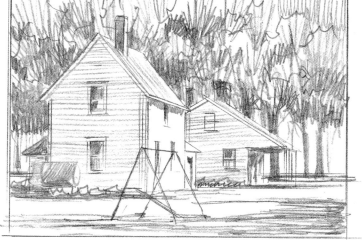

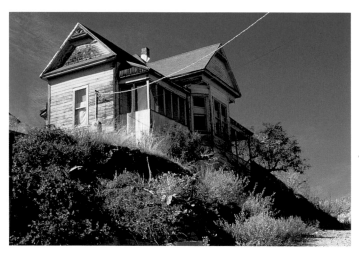

Imagine a Story
At first, this rather neglected Victorian in Virginia City, Nevada, doesn't prompt much of a story, but the rough-and-tumble location in a western mining town makes me think of leathery old guys who've seen better days.

Perhaps I'll put in the silhouette of an old cowboy in a Stetson walking away in the shadows. Then, to keep from getting too depressing, add a wisp of smoke from the chimney and a bright, snappy American flag hanging from the front porch.

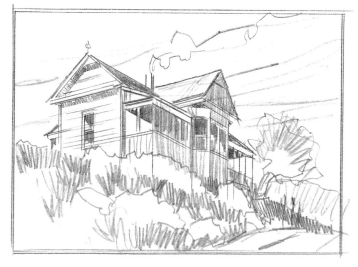

Imagine a Story
This house in an Ozarks hill town, with its eclectic architectural elements, conjures a feeling of genteel southern femininity. I envision ladies on the veranda with cats on the rail amid bowers of flowers inspired by the foreground vine. I might add a brick path leading into that pleasant hospitality.

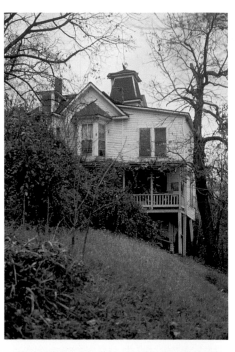

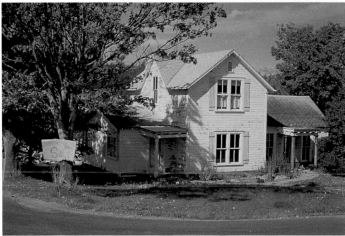

Imagine a Story
Houses like this are common in small towns in the Northwest. Today there's a yard sale sign nailed to the tree out front, but only the sign. It will be a challenge to add the yard sale myself, drawing from other sources and using the house and foliage as a backdrop.

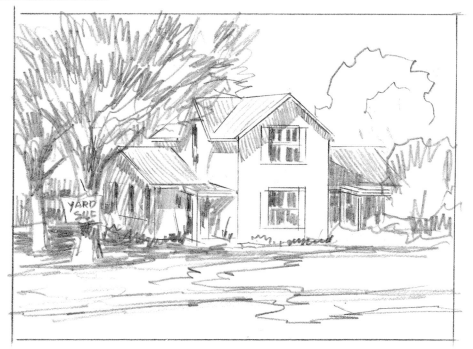

Frame an Old Subject in a New Way

I f you want to paint a familiar land-
mark, give it a fresh twist. Perhaps
there's a classic building that's been re-
corded and photographed in every way
since its construction in 1887. To find
a different camera angle and line of vi-
sion, move around, cross the street, re-
position yourself. Think about incorpo-
rating everyday objects that might seem
mundane or even ugly at first.

In these examples, I've used common
landmarks but in entirely different
ways.

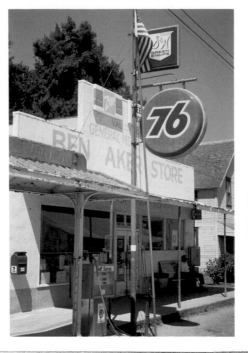

Use Slides

Slides are preferable to prints be-
cause the colors are truer and the de-
tails are clearer since a slide can be
projected to any size. They are more
economical than prints, which ap-
peals to my Scottish nature.

Change the Center
of Interest
Notice that the '76 Station
is not the composition's
center of interest. Instead I
have used it in shadow as a
framing element to draw
the eye down the road.

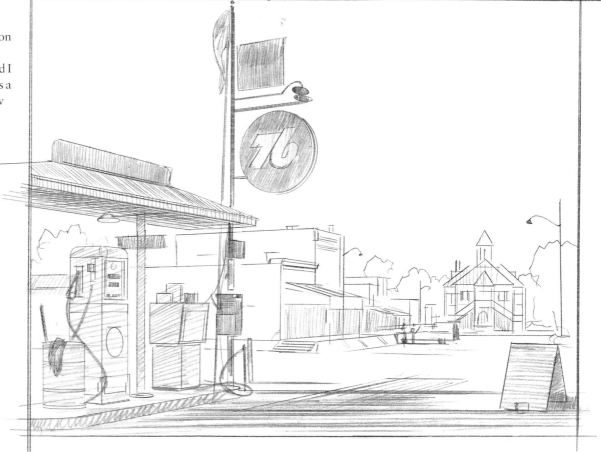

Develop the Foreground

This drawing uses the domed landmark as the center of interest, but I still had a lot of fun developing the foreground. The lamppost, mailbox, fire hydrant, street signs and hard-hatted worker looking down a manhole are added elements from other sources.

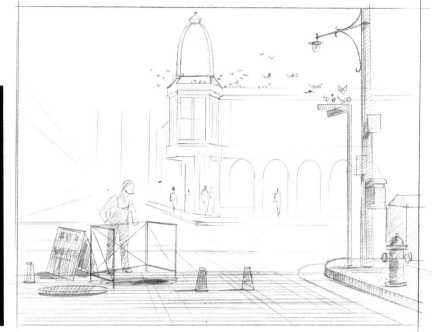

A Different Angle

Always try to see things from a different or unusual angle. Here, a church is viewed through the cemetery behind the structure instead of from the expected front entryway. This opens new possibilities for a story. I like the dark foreground because it contrasts the whiteness, light and purity of the church with the somber heaviness of the graveyard.

Reference Collection

These photographs are examples of using the camera to collect reference material for framing and foreground interest. I may never use the same foreground together with the subject in a particular slide, but will more likely match it with a different subject.

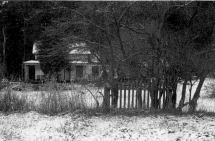

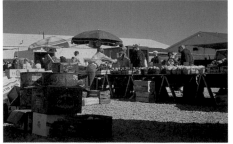

Make Foregrounds Work for Your Story

How important the foreground can be to a composition! The ground itself can be used as an artful tool to draw the viewer's eye into the center of interest. Directional shading (dark to light), cast shadows, changes in textures and different types of tire tracks are handy, too.

I like to frame my compositions with a dark foreground even in photo references. It's a way to add depth and draw the viewer into the center of interest. Trees, shrubbery, fences and shadows of either tall structures or trees that aren't in the picture are useful framing elements.

Keep your eyes open for unique, colorful things that people have in front of their houses, which give hints about the personalities who live within. Your reference collection should include plenty of mailboxes, fence posts and gates.

FOREGROUND DETAILS

Careful planning and rendering of the ground leads the viewer into each painting in the color studies here. Foreground details give clues to the story line, prompting curiosity. For example, recently made tire tracks indicate that someone has just driven into the story. What sort of person drives that particular make of car? Why would anyone venture out in such weather? Other foregrounds provoke different lines of thought. Who mows that dandelion-speckled lawn, and how often?

Darker Value in Foreground
Here's a clean front yard, but notice the foreground. See how a darker value and some subtle tire tracks lead the eye into the composition?

Contain Clutter
The same study done as an unkempt autumn yard with fallen leaves and weeds. Notice how busy it gets. Strive for an interesting foreground but guard against having too much clutter compete with the center of interest.

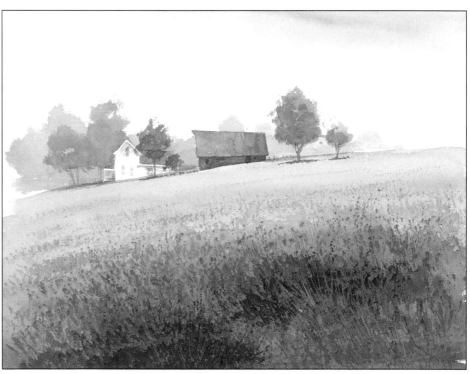

Exciting Weed-Like Shapes
An open field can frame a composition by getting darker and more detailed as it nears the viewpoint. Here I started with a light wash, working wet-into-wet, and got darker as I came down the paper. This takes practice, but as the paper dries, lots of exciting weed-like shapes appear, inspiring you to carry on.

FOREGROUND TREES

Examples of Painting Foreground Trees

A foreground tree, since it's closest to the viewpoint, has more detail than the other foliage. I paint in general leaf areas with a fan brush. After the first wash dries, I go back with a matching opaque and add textures showing light on dark. Here I've added bushes and completed the ground cover. The shadows are long horizontals, reaching across the page to add depth. The foreground dirt and gravel is a combination of splatter and drybrush showing texture and direction.

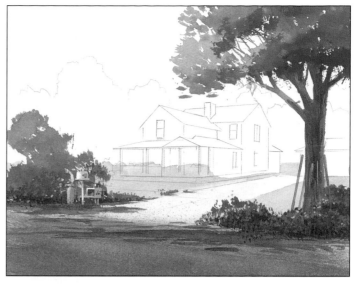

Keep an Open Eye

Almost any residential street scene lends itself to framing by a foreground tree, fence, mailbox or shrubbery, singly or in combination. An interesting fence with an open gate invites the viewer into the painting. Additionally, dark shadows along the ground in successive horizontal patterns help describe planes and depth.

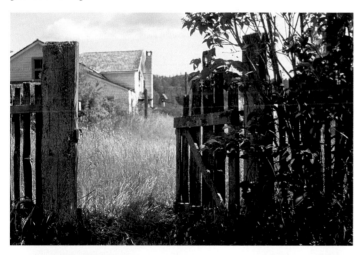

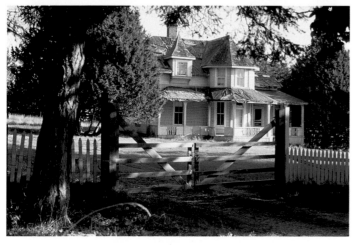

Splatter Brush

To create interesting foreground texture, I use what I call a *splatter brush*. This is an old brush that's disintegrated into many points where I've kind of scrumbled against its natural shape. While the paper is still damp, I splatter dark and light paint onto the foreground to indicate flowers, seedpods and even bugs. Have fun!

Materials

I'm a wash and gouache painter. I take a painting as far as possible in watercolor washes, then fine-tune it with gouache, an opaque mixture of transparent watercolor and white casein.

I work in my studio from photographs and slides. I often use a table-mounted slide projector to cast slide images onto my work surface.

PALETTE

My palette consists of:
- Burnt Umber
- Burnt Sienna
- Raw Sienna
- Cadmium Yellow
- Cadmium Red
- Alizarin Crimson
- Prussian Blue
- French Ultramarine Blue
- Lamp Black
- Payne's Gray

I use an ice cube tray to hold the paints, squeezing out an entire tube into each individual compartment. When not painting, I cover the tray with a damp towel topped with mat board to keep the paints from drying out. When ready to paint, I rewet the paints and stir until they're the consistency of soft ice cream. This always keeps the paints at ready-to-paint consistency and cleaner than most commercially available palettes.

I mix colors and gouache on my 12" × 19" (30.5cm × 48.3cm) white enamel butcher's tray, but sometimes I wet-blend directly onto the paper.

PAPER

I use 112-lb. (240g/m²) rough Strathmore watercolor paper mounted on Crescent board that requires no stretching, takes a lot of abuse and simplifies framing.

BRUSHES

I use large flats for sky washes and covering large areas but my favorite brushes are ⅛-, ¼- and ½-inch lettering flats, and small no. 1 and 2 rounds for fine detail. Sometimes I even shave these down for a precision point. I like my old distressed brushes that I've trimmed, chiseled, sharpened and even stiffened with glue. These are fun for creating exciting textures and varied foliage.

SCOTCH MAGIC TAPE

I find Scotch Magic Tape the most user-friendly tape to my painting approach. As a mask or resist on Crescent Strathmore 112-lb. (240g/m²) rough watercolor board, it holds well and comes off easily, leaving no sticky residue. I press it lightly onto the board, make any necessary cuts with a small, sharp craft knife, then burnish with my thumbnail.

SARAL TRANSFER PAPER

This graphite transfer paper works beautifully for tracing sketches to watercolor board. The graphite lines can be erased or painted over. There's also a white transfer paper that is handy when transferring onto a dark background.

LIQUID FRISKET

There are various brands of liquid masking fluid available. I use it to mask fine detail or irregular shapes that are too complex for Scotch Magic Tape. I usually thin it with a few drops of water for smooth application.

MECHANICALS

STRAIGHTEDGES I have a collection of T-squares and straightedges, long and short, including my six-foot-long architects' straightedge, which I use depending on the scope of the composition and the size of my table.

ELLIPSES Ellipse guides (flat sheets of pliable plastic with stencils cut in varying degrees and sizes of circles in perspective) are necessary for drawing wheels, cans, buckets, flowerpots and so on. Just to fulfill my vanity, I have a complete collection of them, but a composition can be arranged so a basic set should suffice—¼ inch (.6cm) to 3 inches (7.6cm) in degrees of 15, 30, 45 and 60.

CURVES One small and one large French curve will do about anything from angel wings to truck cabs. Ship curves are long, shallow-curved shapes that I only use occasionally, but they're perfect for long, curved tire and railroad tracks or overhead wires.

Do What Works

I don't worry about traditional watercolor methods such as painting negative space around a lighter area. If it's easier to paint a white post in opaque, that's what I do.

BRIDGE

The bridge is a necessity to render sharp details in architecture, vehicles, pavements, fences and the like—wherever straight lines and crisp edges are needed.

Artist's bridges are available through many art supply houses or you can make your own. The diagram on this page shows one way to construct your own bridge. Make variations in size according to the size of your hands and the intended use of your bridge. I also have one that's twenty-eight inches (71.1cm) long that I use in large architectural renderings.

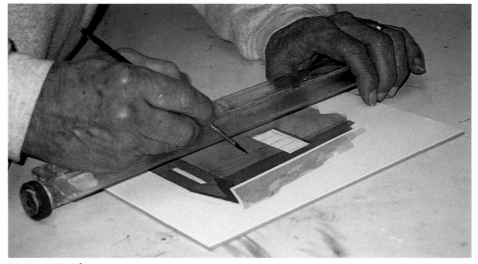

Using a Bridge

Here I show my bridge and how it's held as I paint in crisp, straight lines of bricks. It's always in my left hand as I paint. It comes in handy when I need to touch up an area or get fine detail while the wash is wet.

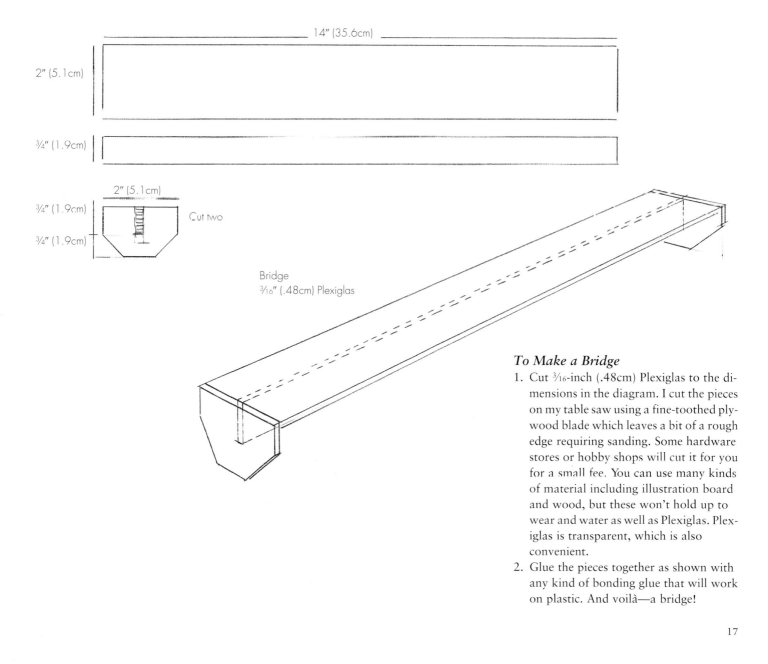

14" (35.6cm)

2" (5.1cm)

¾" (1.9cm)

2" (5.1cm)

¾" (1.9cm)

¾" (1.9cm)

Cut two

Bridge
³⁄₁₆" (.48cm) Plexiglas

To Make a Bridge

1. Cut ³⁄₁₆-inch (.48cm) Plexiglas to the dimensions in the diagram. I cut the pieces on my table saw using a fine-toothed plywood blade which leaves a bit of a rough edge requiring sanding. Some hardware stores or hobby shops will cut it for you for a small fee. You can use many kinds of material including illustration board and wood, but these won't hold up to wear and water as well as Plexiglas. Plexiglas is transparent, which is also convenient.

2. Glue the pieces together as shown with any kind of bonding glue that will work on plastic. And voilà—a bridge!

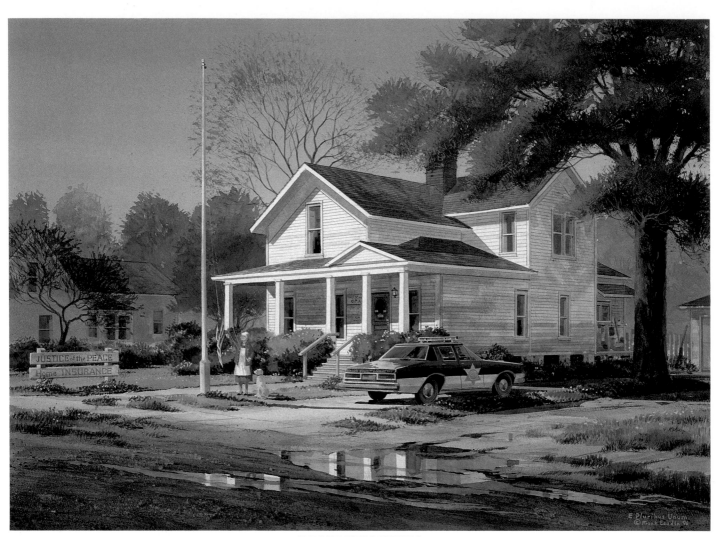

E PLURIBUS UNUM
16" × 22" (40.6cm × 55.9cm)

Chapter 1

Create a Hometown Story Illustration

T he painting we'll complete in this chapter is the perfect reason to always carry your camera or sketchbook with you. While visiting a small Michigan town, I was walking my dog and spotted the scene that inspired this painting.

There's nothing extraordinary about the subject except that it's so typical of "hometown." When that sense of hometown is depicted effectively by a painter, poet or even a movie director, we all feel a warmth in our hearts. As artists, we can create that recognition and emotional response by our selection of a subject and by creative enhancement.

In this chapter, I'll show you how to build character into your paintings as I take you through the steps of this painting—from the initial inspiration to the completed work.

Begin With a Story and Sketch

This is the slide I took on that morning walk with my dog. I chose to work from this one because the components suggested a rich and interesting story line.

The combination of the police black-and-white parked in the driveway, the insurance sign and the flagpole out front is material for several scenarios. It suggested to me that in this neighborhood, perhaps just one person was in charge, which is typical in many small towns.

EMBELLISH THE STORY LINE

In my final composition, I added "Justice of the Peace" and the C.P.A. sign by the front door, along with the flag to embellish the idea that municipal power was concentrated in this house.

To soften the strong patriotic flavor, I added the maternal wife/mother figure and the dog. Their presence tweaks our preconceived assumptions. Could it be that *she* is really in charge? Maybe she is even the town enforcer!

THINK OF A TITLE

A title helps define a story line while developing a painting. For this painting, *The Patriot* seemed too stuffy, *The Enforcer* too strong. The union of so much local power instilled in one person and house made me think of *E Pluribus Unum*, a perfect union. I like the feeling of this title and also the fact that it is a very dignified title for such a humble scene.

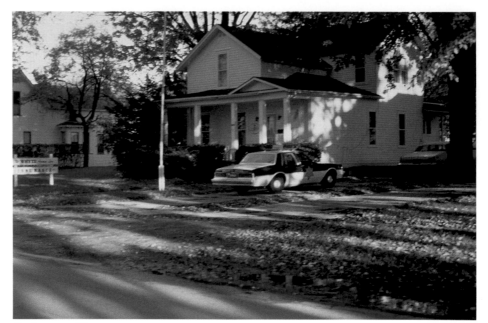

Reference Photo

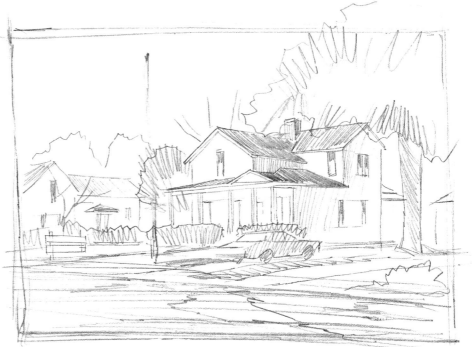

Refine the Composition
With a developed story line, concentrate on refining the composition to reflect what you want to say. Move things around and add or delete elements to create a specific mood and enhance the story. For instance, I've repositioned the car farther to the right, revealing the steps and front door of the house and drawing the eye to the center of interest. The flagpole is moved to the left so it stands free and isn't lost in the planes of the house. I added long shadows across the ground to evoke an early morning mood.

Establish Perspective

Once you're sure of composition, do a basic perspective drawing. I rely on perspective to develop my compositions, so I pin it down as accurately as possible. It's one of the most important steps in planning a painting and I will refer to it throughout this book. But there is no need to become a slave to the mechanics of perspective. Try to develop a working understanding through practice. Once the horizon/eye level and left and right vanishing points have been established, placing properly scaled elements in a composition is easy.

Perspective as Guideline

Fleshing out the perspective lines is an invaluable tool when it's time to apply paint. Every brushstroke should work to describe the plane of the object you are painting. A well-drawn perspective serves as a guideline for the direction of that plane, whether it's vertical siding, roof shingles or a roadway tapering to a vanishing point on the horizon.

To left vanishing point

To right vanishing point

Horizon line/eye level

Figure A

Figure B

Most architectural shapes are boxes, a series of boxes or pieces of boxes. Think of the box in Figure A as a simplified perspective you can fit your house into. This helps with setting planes, angles and establishing corners. The light and shadow sides of the boxes are defined. In Figure B, the basic house box is set into its foundation and the front yard and driveway, determining perspective and scale. Establishing the perspective in the beginning is invaluable.

To left vanishing point

To right vanishing point

Horizon line/eye level

Eye level

Establish the horizon line—usually the longest, most obvious horizontal line at the viewer's eye level. Determine the longest vertical line at your center of interest. From here, trace out to the left and right vanishing points.

Create Depth With Scale

I strive to push the two-dimensional limitations of paint and paper into three-dimensional reality. To do this, you must create the illusion of depth, which naturally draws the eye to the center of interest. An effective way of creating depth is the use of scale. Scale is simply making things larger in the foreground and gradually reducing their size with distance.

I relate everything in my paintings to the human scale, so when planning a composition, I draw a six-foot (1.8m) man at various points in the foreground, middle ground and background to establish scale. I use a six-foot (1.8m) model because I'm a little over six feet (1.8m) tall and my eye level is approximately six feet (1.8m) high. To maintain consistency, I take all of my reference photos at eye level while standing. This way, I can always pin-point my horizon even when I'm back in the studio.

Your eye level may be different than mine, but you can use the same system once you've decided where your horizons will be. Of course, if your viewpoint is from the bottom of a hole or the top of a hill, adjustments will need to be made. Don't forget that the horizon line still remains at the eye level of the viewer.

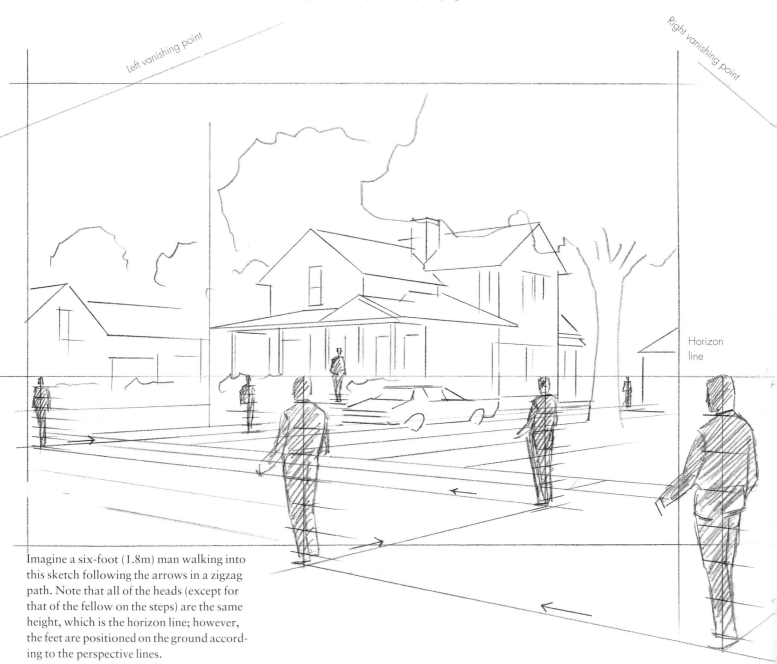

Imagine a six-foot (1.8m) man walking into this sketch following the arrows in a zigzag path. Note that all of the heads (except for that of the fellow on the steps) are the same height, which is the horizon line; however, the feet are positioned on the ground according to the perspective lines.

22

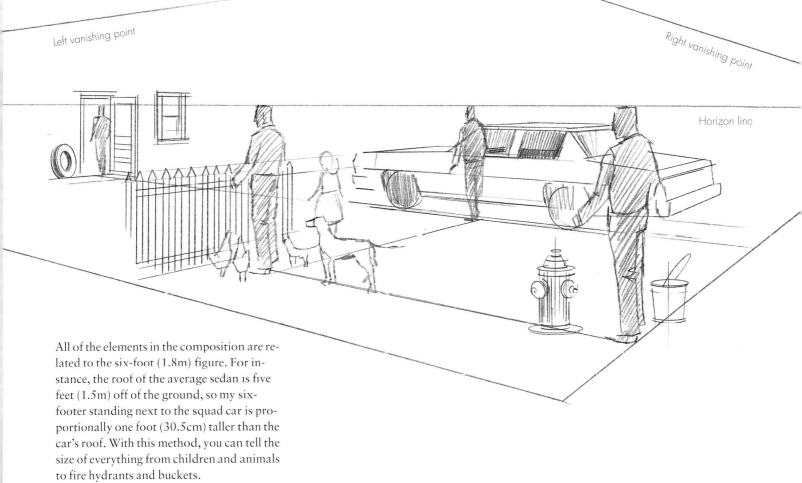

Left vanishing point

Right vanishing point

Horizon line

All of the elements in the composition are related to the six-foot (1.8m) figure. For instance, the roof of the average sedan is five feet (1.5m) off of the ground, so my six-footer standing next to the squad car is proportionally one foot (30.5cm) taller than the car's roof. With this method, you can tell the size of everything from children and animals to fire hydrants and buckets.

Create Mood Through Value and Color

Once your well-planned composition is complete, it's time to decide on the value plan and color scheme. It's a good idea to make a few quick studies, trying variations in values and colors. Keep in mind the values and colors that inspired you in the first place. These quick studies can open creative doors. Sometimes moods and effects that you didn't have in mind will magically appear.

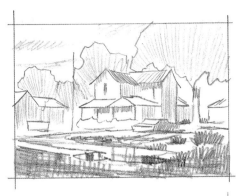

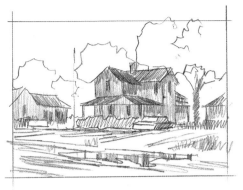

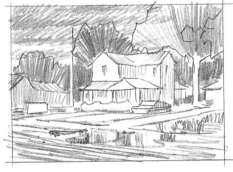

Value Placement to Suggest Story
Make a few quick value studies in pencil. Mentally divide your composition into three separate planes: background, middleground and foreground. Then, using three values—dark, middle and light—assign a different value to each plane. Rearrange them for differing moods, seasons, even time of day. Notice how the value placement in these three treatments of the composition suggests different times and seasons and, therefore, different story lines.

MINIATURE COLOR STUDIES

After finishing your pencil value studies, try some quick miniature color studies to explore the effects of different color themes.

Figure A

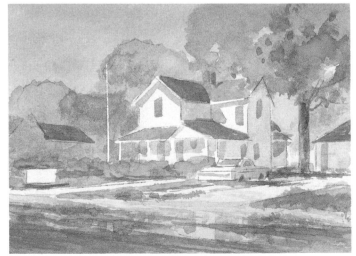

Figure B

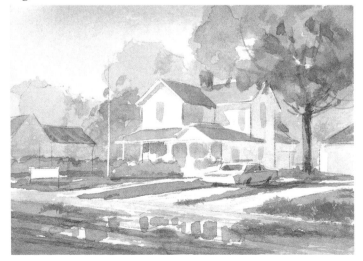

Two different atmospheres are created simply by using different color themes. In Figure A, I started with a wash of Raw Sienna and Burnt Sienna, forcing me to carry out a very warm color scheme. Notice that even the greens are on the warm end of the spectrum. In Figure B, a beginning wash of cool Prussian Blue committed me to a bluish range.

Use Skies to Cast a Mood

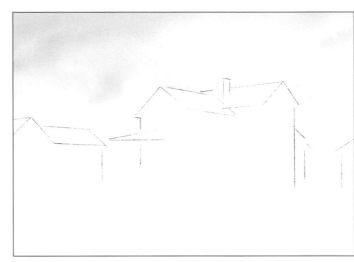

The character of the sky can be as important as anything in setting the mood.

I use Scotch Magic Tape to mask out the foreground and middle ground shapes where they meet the sky so I can wash in the sky with complete freedom. Cover the whole sky area with clean water using a 1-inch flat brush and then float in colors.

Sky techniques take practice. Keep trying to find your own favorites and be inspired by other painters as well as the ever-changing sky itself.

Note how the three approaches to skies on this page cast different moods.

Pleasant
To represent a pleasant summer day, stroke Prussian Blue into the wet sky area using a 1-inch flat. Keep it light, simple and quick. Let it dry undisturbed and do not touch it again.

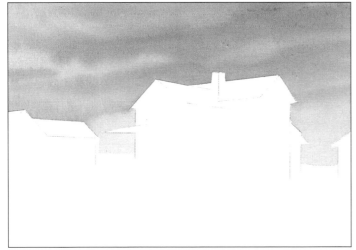

Cloudy
A heavy clouded sky can be about any color depending on what the composition calls for. I try to keep the horizon lighter than the mass of sky overhead. Indicate soft clouds by painting in darker areas wet-into-wet. Be quick with your brush, then stop.

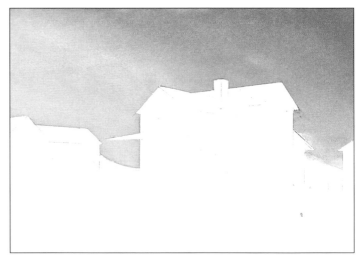

Dawn or Twilight
A graded dawn or twilight sky is effective in a composition containing long shadows. After wetting down the sky area, I stand my watercolor board on end and give it a whack to drain off excess water. With the paper still wet but not runny, stroke in color working from the lightest, warmest area to the darkest, coolest area. The gradation usually moves diagonally across the paper from one lower corner to the opposite upper corner.

Use Quick Color Studies to Stimulate Your Imagination

Even if you are set on a story line, quick color studies can spark a different direction and are fun to do.

Here are three examples of quick color studies combined with varying skies. Each interpretation of the composition evokes a unique feeling and suggests different underlying stories.

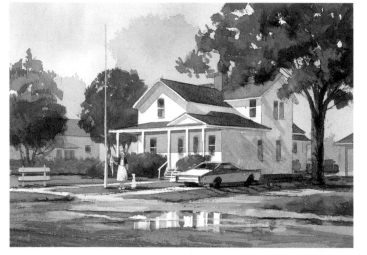

Summer
A soft blue sky and clear greens in the foliage and ground cover say summer. I like to catch the clean feeling that happens just after a rain shower—when the sun comes out and everything is washed and fresh. This also explains the foreground puddle.

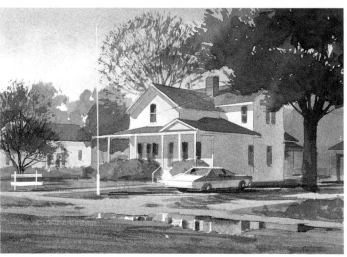

Autumn
To express an autumn day, imagine the subtle haze that colors everything bluish purple and warm sienna. The foliage and fallen leaves are warm October hues. Clouds are hinted in the sky, where violet and Burnt Sienna combine to get a smoky autumn feel.

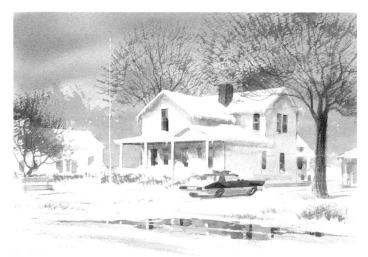

Winter
A winter setting can be warm and inviting. In a snowy scene, use warm blues and grays unless there is a particular reason to make things really cold. Payne's Gray with a touch of Alizarin Crimson or Burnt Sienna can warm things up in spots.

Steps to Paint E Pluribus Unum

Now it's time to paint. Based on my color studies, I've decided to give this painting an early autumn look. The foliage will be warm greens moving from oranges and Alizarin Crimson to violet, French Ultramarine Blue and Payne's Gray. All of this will be beneath a hazy purple/blue sky.

STEP 1

Mask Out Whites

Mask out the main house, roof and chimney. I use Scotch Magic Tape. Here I've drawn a red line on the edge of my mask so you can tell exactly where the tape is. Also mask out the clear whites you want to keep by using liquid frisket. These include the flagpole, sign in the foreground, car, woman, dog and foreground puddle.

STEP 2

Sky and Background Trees

Turn the board upside down and flood the sky and background area with clear water. Using broad strokes with a 1-inch flat brush, put in a solid light violet to darker violet/Prussian Blue wash. Remember, the clear sky is lighter at the horizon and gets bluer and darker overhead.

Once the sky is dry, paint in simple tree shapes with an old brush, allowing the autumnal colors to run together. Work lighter at the top left, becoming darker at the bottom right since the light source is from the top left. The background house is a monotone with simple windows. Everything keeps the same value as the trees behind it.

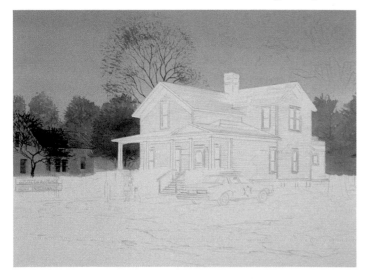

STEP 3

Wash Foreground

Wash in a warm green (mix Prussian Blue and Cadmium Yellow) to Burnt Sienna/French Ultramarine Blue to kill the foreground white before you work on the house. Block in the grass and weed pattern in the yard and driveway. Now clean all those greens off your palette and get fresh water.

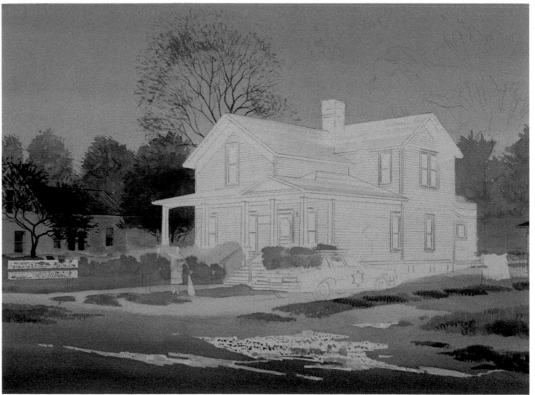

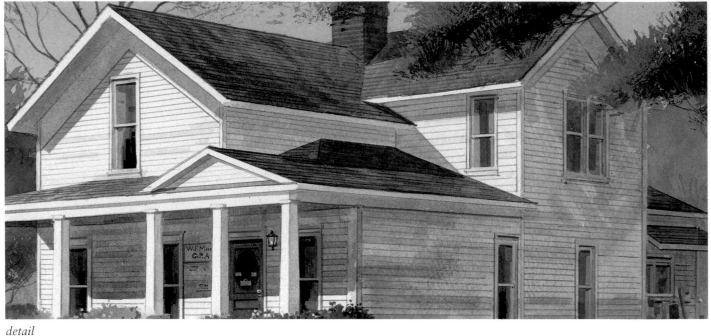

detail

STEP 4

Paint the House

Cover the entire house with a light wash of Raw Sienna with a touch of Burnt Sienna in it and let it dry. This warms up the stark whiteness of the house and gives it a sunny, reflected glow.

Shadow Side. Next, fill in the shadow side of the house, starting at the back right-hand corner and using a mix of Burnt Sienna and French Ultramarine Blue. Complete the shadow side plus the cast shadows on the front porch and under the eaves. Be careful to include the shaded side of the porch posts, window and door trim. Keep brush lines straight and crisp to maintain the angular character of the architecture.

Siding. When dry, use a small, flat letter-ing brush to hint at texture on individual boards and to define the walls. Keep the colors subtle in direct sunlight and darker in the shadows and on the shaded side of the house. I use my bridge (see page 17) to carefully paint in the horizontal siding with a small, pointed brush or rigger.

Roof. Paint the roof with warm colors on the sunny side and a darker value on the shady side. Add texture strokes with a flat brush. The dark ends of the shingles are scored using a small brush and bridge as a guide. Be careful to follow the direction of the roof pitch with your strokes and stay in perspective so the roof doesn't appear warped and broken. (See pages 56-57 for some roof techniques.)

Windows. Most of the windows here reflect the sky, so use a blue/gray mixed from Prussian Blue and Alizarin Crimson. The windows on the shadow side should be the lightest and bluest, working toward the front door where they will be darkest and warmest. This places the greatest contrast in the heart of the painting, which is where you want it. The windows closest to the center of interest should be the darkest value in the whole composition. Punching dark holes in a white house creates such a strong contrast that it seems we can actually see inside.

Fine-Tuning Tips

When a painting is finished, I sit and look at it for awhile. Let it rest overnight, go to work on something else, then come back with fresh eyes to make changes. In art school we learned to turn our backs to the work and, holding a mirror in front of us, look over our shoulders to view the composition in reverse. This is sometimes a revelation; the composition should hang together just as well in reverse as it does straight on. It also helps to view the work through a reducing glass to see what it looks like in miniature where only the large value patterns and shapes are important.

at right

STEP 5

Finish With the Foreground

When the background and middleground areas are painted, it's time to focus on the foreground. Keeping in mind that the foreground tree has more detail than any of the foliage, paint in leafy areas with a fan brush. After the first wash is dry, keep the light source in mind and go back in with matching opaque to add some leaf texture showing light on dark. Remove the frisket from the puddle areas and paint in reflections. Remove all of the remaining frisket and paint in the signs, squad car and flagpole. Paint the figures last.

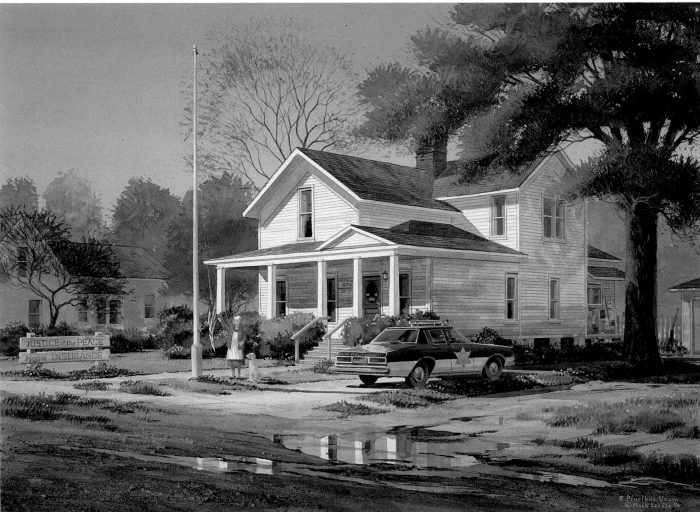

E PLURIBUS UNUM
16" × 22" (40.6cm × 55.9cm)

"*Folks claim the center of town is the Courthouse Square, but a couple of blocks up on Maple Street, in an unassuming white frame house, lies the ultimate authority. This is the source of the last word, whether from he or she; the Marshal and the J.P. Here the Unum is Pluribus and secure.*"

Landscape Tips

USE LANDSCAPE ELEMENTS TO TELL YOUR STORY

In every composition throughout this book, I've carefully planned the landscape, whether it's the street, the trees or just dirt. The character of the landscape can be your whole statement or simply a complementary backdrop for your main story.

A window box can be the center of interest or an added element to brighten an uninteresting area.

FLOWERS AND SHRUBS

Most hometown scenes include some kind of foliage or flowers even if it's only a pot of geraniums. Use plants to soften and humanize an old building. Be on the lookout for interesting planters, flower combinations, trees and shrubs to add to your photo or sketch reference collection.

Perky Plants

Most leafy patterns are pointed, so keep your plants perky and uplifted as you paint. Don't render every leaf. Paint a good basic shape and indicate a few areas of leaves.

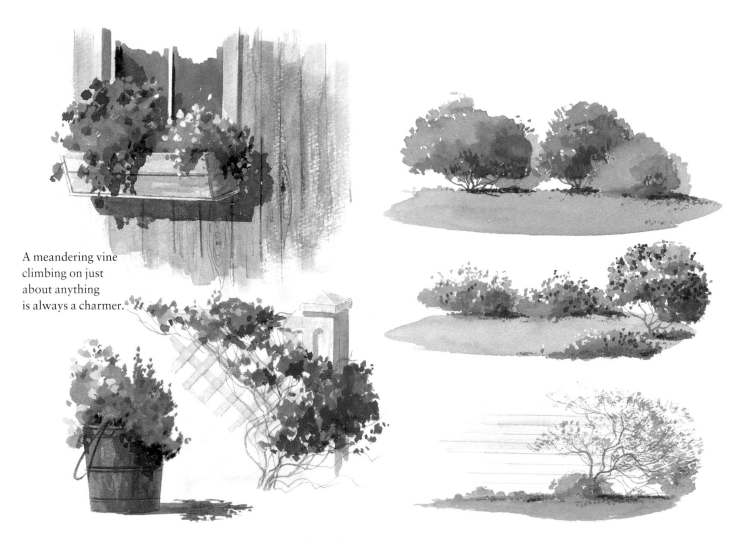

A meandering vine climbing on just about anything is always a charmer.

A simple pot of flowers is a colorful addition to almost any hometown composition, and people often set them in unexpected places.

There is always some kind of plant along a building's foundation, even if it is only weeds. Practice simple shapes of weeds, bushes and vines to build a repertoire of patterns.

PUDDLES

Puddles can be a dominant feature, or they can be used to give interest to a foreground or to help describe the character of the ground or pavement. Plan carefully and draw them into your composition in the beginning. Also, plan what you intend to reflect in your puddles and how it will contribute to the overall composition. (For more techniques on reflections, see page 92.) I usually paint my puddles last so I know exactly what colors and shapes to reflect.

Mirror colors Contrast with earth

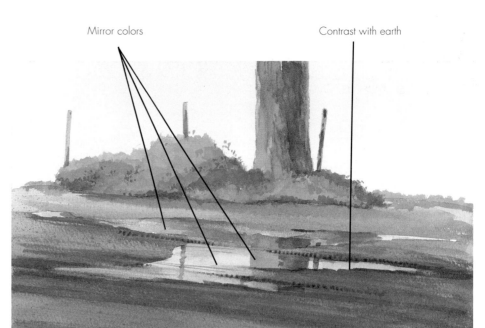

Lift off pigment for a streak of light Mirror colors

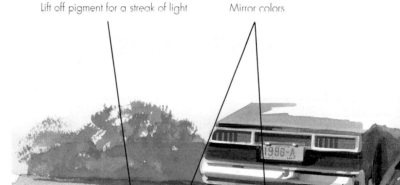

Steps for Puddle Painting

1. Use liquid frisket to retain the white of the paper in the shape of the puddle while you're working on the surrounding areas.
2. When you're ready to paint the puddle, remove the frisket and drop clear water into the puddle shape.
3. Before the water is dry, drop paint from a fairly dry brush in the shapes and colors mirroring those found just beyond the puddle. Keep it loose and suggestive. The edges of the puddle should be in contrast to the surrounding earth.
4. A streak of light across the surface says shiny water. To achieve this, allow the final wash to dry, brush on clear water, then quickly lift off pigment with a dry paper towel.

More Landscape Tips

STREETS AND WALKWAYS

Streets and walkways are integral parts of a composition. Different types of surfaces give character to the atmosphere and mood of a story. When painting streets and walkways, be sure your brushstrokes always follow the direction and contour of the planes described in your perspective drawing.

BRICK WALK/ CONCRETE PAVEMENT

Look carefully at the pattern created by the way bricks are arranged. It's not necessary to paint every brick. Pick a group of individual bricks to indicate size and color, then paint the most prominent area in detail and suggest the rest.

When painting concrete, think of the irregularities in your washes as dark or light patches in the roadway. When the last wash is partially dry, splatter paint in some areas with a toothbrush to indicate loose gravel. Make it look dirty!

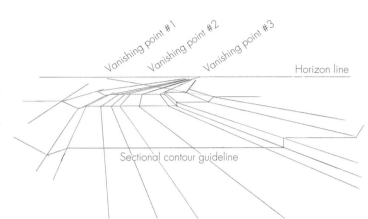

Vanishing point #1 Vanishing point #2 Vanishing point #3 Horizon line

Sectional contour guideline

Perspective Guide
Here's a sketch to help lay out perspective so that your roads, streets, ditches and sidewalks stay flat on the ground and remain in scale.

Bricks

1. Draw in all the pencil lines needed to establish perspective guidelines.
2. Paint the entire area with a light value wash, let it dry and then go back in and define the planes with a darker wash. I've found Cadmium Red and a touch of black, of all things, produces a good, earthy red brick color.
3. Now define individual brick shapes with an even darker value. Don't get too red.

Concrete

1. Draw in perspective guidelines.
2. Lay down a broad, free wash of French Ultramarine Blue and Burnt Umber using a large, flat brush.
3. Go over the first wash with several washes of darker glazes. Move from a dark, cool wash in the foreground to a warmer, lighter wash toward the center of interest. Be sure to keep the perspective correct. Define cracks, patches and changes in tone and texture as you go.

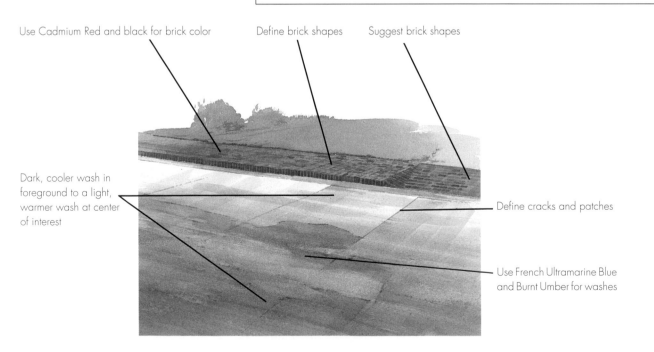

Use Cadmium Red and black for brick color

Define brick shapes

Suggest brick shapes

Dark, cooler wash in foreground to a light, warmer wash at center of interest

Define cracks and patches

Use French Ultramarine Blue and Burnt Umber for washes

STONE WALK/GRAVEL STREET

Stone Walk

1. Wash in a mixture of French Ultramarine Blue and Burnt Sienna. Sometimes I sneak in a touch of Raw Sienna.
2. While this wash is wet, blot, dab, scrape and drybrush to work up a rough texture indicating individual stones.
3. Using a tiny brush, paint a few selected dark cracks to help say stone and suggest a pattern.

Gravel Street

1. Here you can go against everything you are told *not* to do with watercolor. Instead of avoiding mud, try to make it. Put in a grainy wash of French Ultramarine Blue and Burnt Umber.
2. Then splatter, drybrush, even drag your thumb through wet places. Go for wonderful, accidental texture while staying within the bounds of scale and perspective.
3. After the first wash dries, indicate ruts, smooth areas and rocky spots. Keep your strokes in the same directional plane, even as you splatter and smear. Cover the rest of your painting when you splatter gravel, or you will have to paint a flock of birds in the sky to cover up wayward splats. Have fun painting dirt! You can't be too messy in this area.

Use a mixture of French Ultramarine Blue and Burnt Sienna

Cover when splattering

Use a tiny brush to paint dark cracks

Use a grainy wash of French Ultramarine Blue and Burnt Umber

Splatter, drybrush, drag your thumb through wet areas

Indicate ruts

CONCRETE WALK/BLACKTOP STREET

Wash with French Ultramarine Blue and Burnt Umber

Add patches and potholes, but don't clutter

Keep brushstrokes in the direction of traffic

Concrete Walk

1. Draw in perspective guidelines.
2. Use a wash of French Ultramarine Blue and Burnt Umber.
3. Go over the first wash with washes of darker glazes. Define cracks and patches. You might put in a few blades of grass growing in the cracks. Don't overdo it.

Blacktop Streets

1. Use a wash of French Ultramarine Blue and Burnt Umber, but this time, use more blue than umber since blacktop has a bluish tone.
2. Keep your brushstrokes in the direction of the traffic flow.
3. Add patches and potholes to give character after the first wash. However, blacktop pavements are often in the foreground and serve as conduits toward the center of interest, so don't overcomplicate and clutter them with too many cracks, patches and puddles.

35

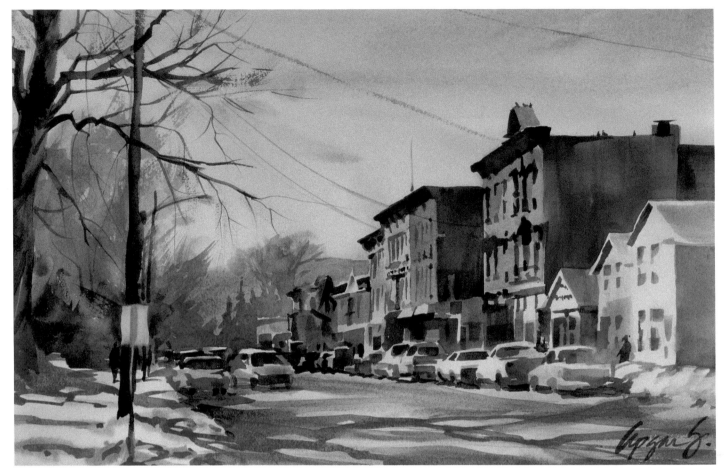

MAIN STREET SHADOWS
Watercolor, 15" × 22" (38.1cm × 55.9cm)

E l i z a b e t h A p g a r - S m i t h

Commissions have always been a problem for Betsy. "My focus becomes clouded with anxiety as I try to paint someone else's idea." Instead, she keeps her buyers happy with compositions of neighborhood street scenes—sometimes covering five houses in one composition—local landmarks, community events and business interiors. *Main Street Shadows* captures a bright winter morning in the village of Schoharie, New York. Postcards of this painting sell like hotcakes at the local soda fountain/pharmacy.

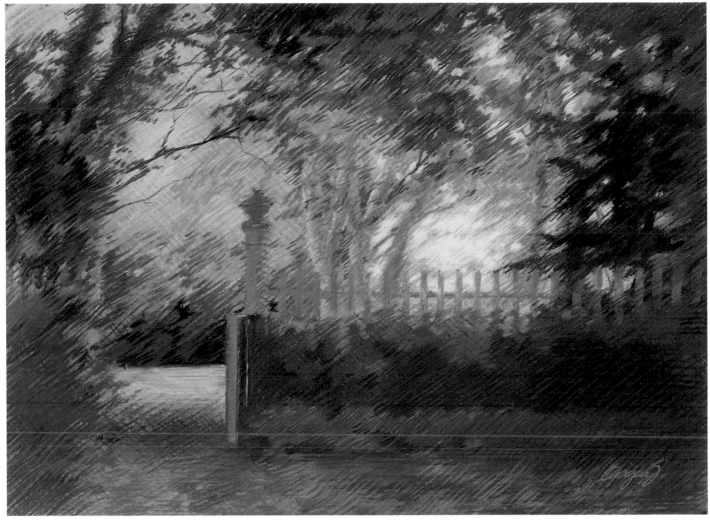

NEIGHBOR'S GATE
Pastel on paper, 18″×24″ (45.7cm×61cm)

Elizabeth Apgar-Smith

Betsy feels that a great painting "captures the viewer's imagination; it connects him with what the artist is trying to say. If the intended mood comes across, then it's successful." In *Neighbor's Gate*, the warm light of the approaching sunset draw the viewer into the painting.

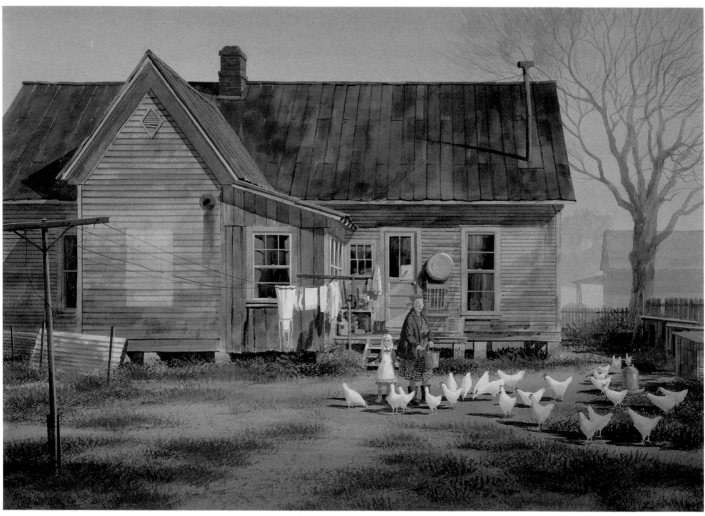

APRON STRINGS
16″×22″ (40.6cm×55.9cm)

Chapter 2

Pathways to a Painting

∞

A single reference photograph or sketch can serve as a springboard for several ideas. Exploring possibilities and deciding which direction to take is a fun part in the process of creating a hometown story illustration.

There are many ways to get there, but the trick is to select a story line and use only those elements that enhance or move it along. The painting *Apron Strings* is more the result of eliminating things from the original reference photo than of adding interesting items to enhance the composition. On this location, there were chickens, pigeons, rusty old tools, an orange cat and hounds sniffing at my heels—a lot of stuff that needed organizing.

Color Studies to Create Mood

I did these color studies and decided to use the warm, orangy color scheme for a couple reasons. First, I thought it would be fun and unique to put down a pale tomato soup-colored wash and work from there. The cooler, bluish wash made the scene seem depressing to me. Second, as I decided what to include in the composition, it became clear that my story line was about hominess, trust, interconnectedness—qualities and characteristics best expressed by a warm palette.

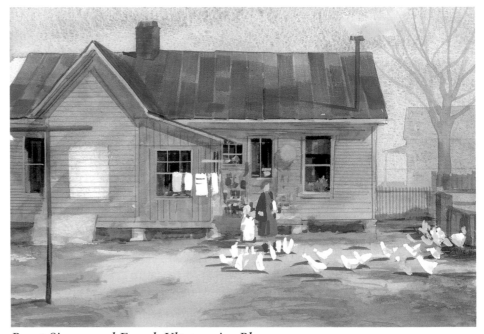

Burnt Sienna and French Ultramarine Blue
Here I masked out the whites of the woman and child, chickens and laundry, and then washed the whole upper half of the board—sky, background and house—with a mix of Burnt Sienna and French Ultramarine Blue.

Orange
Again I masked out the whites and then washed the whole board with an arbitrary orange color to start with an unusual hue. See how warm this underlying wash makes the whole study? This is a good exercise to help you get out of the rut of painting a blue sky all the time.

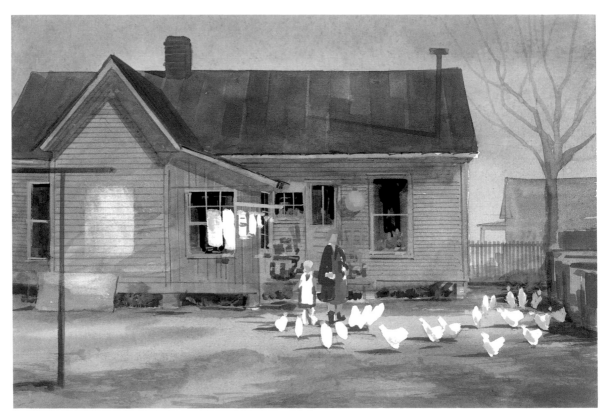

Steps to Paint Apron Strings

STEP 1

Save Whites and Apply Orange Wash

Transfer the final drawing to watercolor board and use liquid frisket to save the whites of the chickens, laundry and clothing. Since all of the other shapes in the painting will be darker than the sky, there's no need to mask out anything else, and you can freely apply a warm orange wash over the whole board. Keep the area near the horizon lightest, going darker in the sky and foreground.

STEP 2

Background Shapes

When dry, add the background shapes using a darker value of the same colors. Then paint in the tree and start the chicken pens at right.

The Personal Touch

It gives a warm, personal touch to a painting when a reference from your own experience is included. For example, I remembered what my mother's daily work clothes and galoshes looked like as she tended her flock of feathered friends.

Other Hometown Views

BLOOMINGTON PORCH
Pen and Ink, 20"×30" (50.8cm×76.2cm)

Gary Simmons

While in school in Bloomington, Indiana, Gary walked past this porch on his way to campus. The porch was on the back of an old house whose backyard was strung with a clothesline. The light in the afternoon would rake this yard and the porch with a wonderful contrast of shadows and highlights. In particular the highlights were in the stacks of soda bottles listing against the railing. The blanket on the clothesline provided a large area of contrast against the light and seemed a fitting statement about casual living in a casual house. It was a perfect challenge to create a combination of the shapes, values and textures in pen and ink.

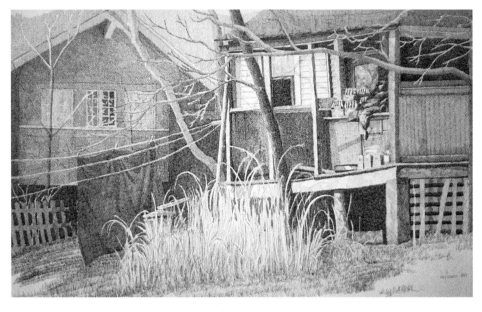

STITT HOUSE
Pen and Ink, 20"×24" (50.8cm×61cm)

Gary Simmons

The Stitt House is a historic home that also serves as a bed-and-breakfast inn in Hot Springs National Park, Arkansas. It features a summertime view that emphasizes the porch's Victorian structure. The mood is intended to be one of intimacy and lushness, which would have been difficult to portray if more of the building were included in the composition. The actual technical handling of the pen work is a little diffused, which keeps the shapes from being too sharp and helps the drawing feel more like an interpretation and less like a photo image.

LIGHTS ON
Watercolor, 7½″×11″ (19.1cm×27.9cm)

Elizabeth Apgar-Smith

The somber mood as the sun sets on a cold autumn evening in *Lights On* is countered by the inviting warm light streaming from the windows of a house as darkness envelops it. "This is a scene I see often from my studio window, so the small watercolor was easily painted from memory," says Betsy. She first did a warm wash to include both the sky and building area. Over that, in complementary blue tones, she painted the large, dark shape suggesting the interesting angles of the Victorian house and tree line, leaving the window areas to glow.

TUCKED AWAY
Watercolor, 15″×22″ (38.1cm×55.9cm)

Elizabeth Apgar-Smith

On a bright, summer afternoon, this humble barn seemed an inviting subject. Located in the northern Catskill Mountains, not far from her home, the small shed-like structure was streaked with sun and offered cool shelter to the tractors nestled in its stalls. While not a particularly impressive piece of architecture, Betsy's painting brings dignity to a common rural subject.

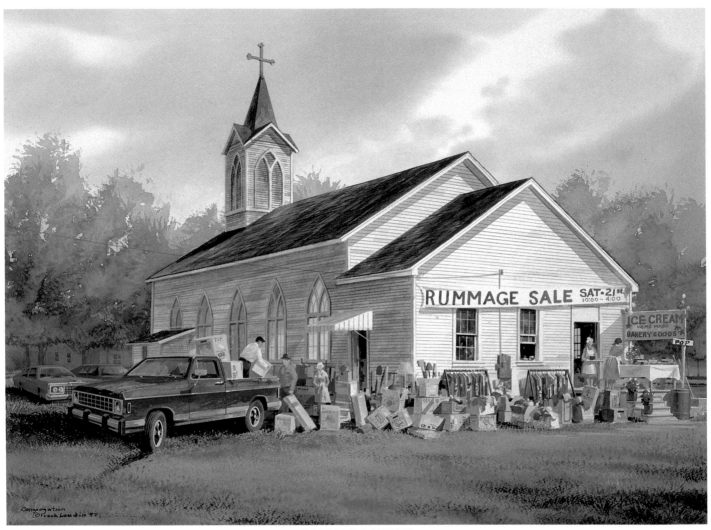

CONGREGATION
16″ × 22″ (40.6cm × 55.9cm)

Combine Elements to Paint a Hometown Story

∽

There are three ways to develop a composition: add elements, delete elements or stick with the composition in the reference photograph.

In chapter one, the painting was true to the original scene. In chapter two, the composition was developed by eliminating elements in the reference photo. In this chapter, I'll show you how adding elements from other resource materials combines with a bare-bones, not-so-interesting structure to create a vibrant story illustration depicting your hometown.

Public buildings are ideal backdrops for this exercise because they're often nondescript or have been photographed and painted so often that a fresh interpretation is needed to keep them from becoming trite.

So grab your camera or sketchbook and take a walk around town. Look for buildings that have strong architectural lines and suggest possible scenarios to you.

Begin With a Story and Sketch

Look at familiar buildings from different angles and sides. It doesn't matter if your subject is basically dull, because you, the artist, have the ability to create a story line from nothing.

Here are three examples of story ideas developed around ordinary public structures.

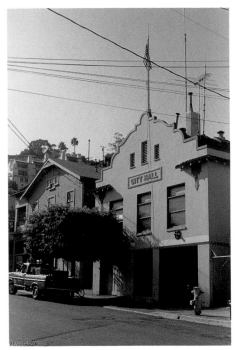

This is city hall on Catalina Island, California, where I lived for years, so I know it well. This public building is typical of many small towns, but since it's located in a tourist town, it's been photographed and rendered in every imaginable form through the years. For a fresh perspective, create your own story line. Here I've marched in a troop of preschoolers, Brownies or whatever you'd like to call them. They gather around the hero of the moment in rapt attention. (Well, most of them anyway!)

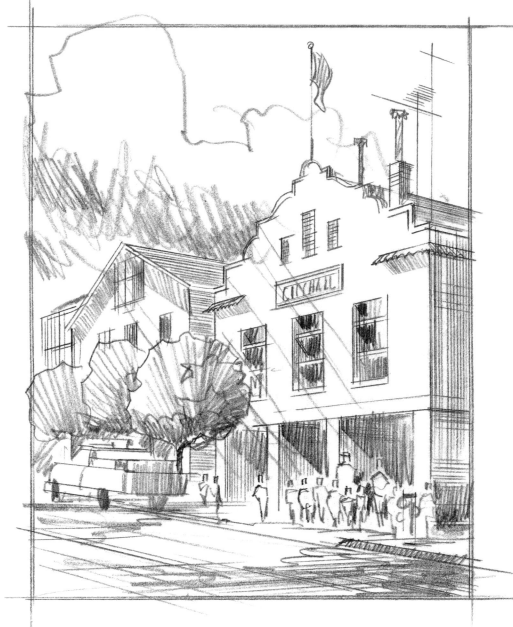

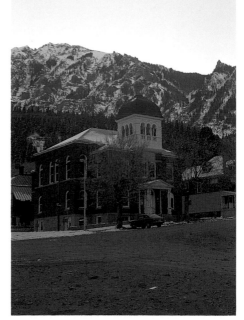

This courthouse is in Ouray, Colorado, where there's usually a lot of snow. The reference photo is cold and dark, so I added snow with some falling flakes. Some kids in colorful clothing and a few lighted windows in this classic brick Victorian help brighten the day.

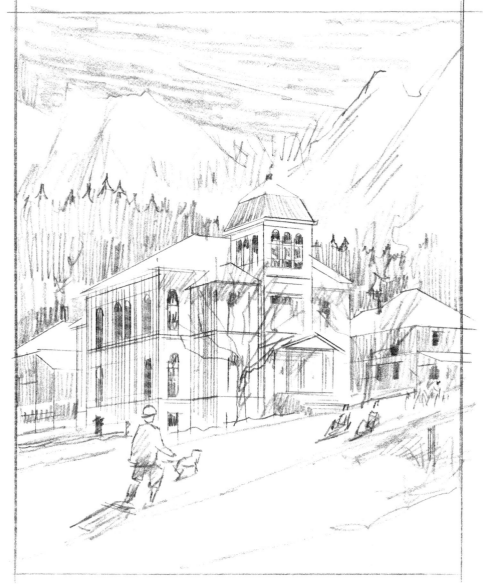

This stone courthouse in the Missouri Ozarks is a wonderful subject. The feeling here could be woven around the idea of the solid permanence of stone and constitutional law, the quiet strength of natural building materials rising out of native soil to provide protection and order for freedom and civil rights.

I add a flagpole and a group of legal-types—jurors, a judge, some attorneys. The flock of birds allows us to escape all of that and flitter off into the sky of imagination.

Experiment With Mood

For this exercise of creating a story line from nothing, I've chosen the back of a church in Louisiana as my backdrop. I wasn't sure why I bothered to take this photo—at first glance it seems dull. But upon closer scrutiny, I noticed the gothic stained glass windows, unusual in a small-town church, and the imposing belfry in need of paint. Also, the back part is probably an added-on kitchen and social room.

So ideas for story lines begin to percolate. This time, let's experiment with a few, simple color/mood studies before the pencil sketches. It's fun and might lead to a story idea. Notice how the colors, seasonal setting and time of day evoke distinctly different moods in the same sketch.

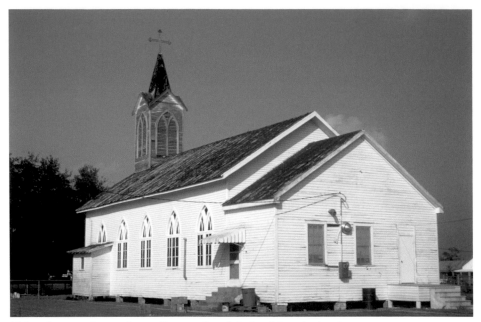

This reference photo of a small-town church in Louisiana is simple and, at first glance, uninspiring. But the shape of the building is strong; the large, definitive shapes of the roof and bell tower counter the simple, flat plane of the back of the building, balancing the whole composition.

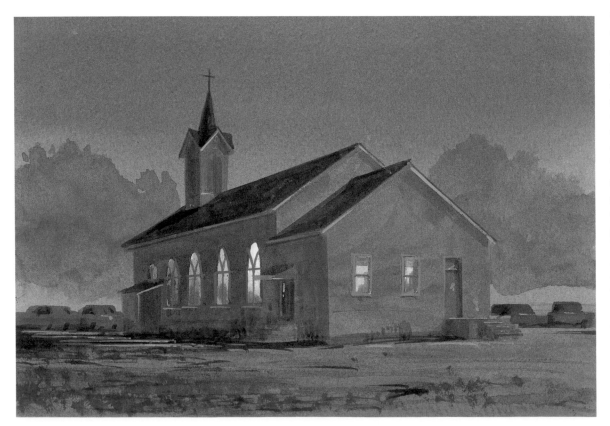

Twilight

With such beautiful windows, it would be a shame not to try a night or twilight scene. Mask out the windows to save the white paper, and wash the entire board with purples and blues. Add greens and earth colors to the foreground. Since the building is white, it reflects the colors of the sky but darker. The colored windows are icing on the cake, and car shapes around the front of the church hint of activity. An evening prayer meeting perhaps?

68

Autumn

An autumn color study offers an opportunity to see how warm fall colors complement the whiteness of the subject. A harvest potluck or Halloween party come to mind. An autumn sky to me has a hazy purplish cast, so I use a wash of Winsor Violet and Prussian Blue. Notice how the windows are almost black when in direct sunlight. On the shadow or "turn side" of the building, windows normally reflect the color of the sky. The far window is the same purple as the sky and almost the same value as the building. The windows become darker as they proceed toward the center of interest where the strongest value contrast occurs.

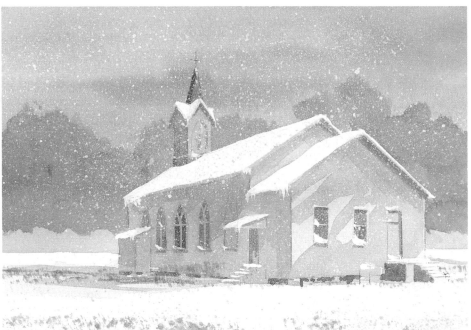

Winter

Blanketing the church in snow suggests a Christmas theme. Use liquid frisket to protect the large areas of snow, particularly on the roof, so you're free to work in the sky with large strokes. Once the sky wash dries, paint in the background trees loosely. The walls can be either light with dark windows, or dark to better show off the backlit stained glass windows. Note the colors of the windows move from cool to warm as they approach the center of interest. Keep your colors on the warm side unless you want to chill the viewer. I use Payne's Gray, French Ultramarine Blue or any blue that's on the red as opposed to green side.

STEP 5

Texture for Walls and Roof

I enjoy adding texture to walls and roofs. Using a darker, cooler mixture of the same Burnt Sienna and French Ultramarine Blue as in the first wash, darken under the eaves on the shaded side with a series of glazes. Since the belfry is in need of paint, make it darker and warmer to indicate natural wood showing through the chips of white paint. The roof is at an angle where it can't be clearly seen, so it needs only a hint of pattern. Use a bridge when rendering architectural features on this scale because it's important that the lines and washes be straight, crisp, in scale and in perspective.

STEP 6

Fine-Tune

After painting the boxes and rummage across the middleground, I see that the foreground needs to be darker and greener. I rewash the foreground area with a pale green and as the wash dries, work in deeper greens wet-into-wet with a fan brush. I'm careful to keep the texture to a minimum so it doesn't compete with the complex pattern of the boxes.

Add colors and values along the box area, including colorful racks of clothing and garden implements against the wall. Printing and labels on the boxes provide interesting detail.

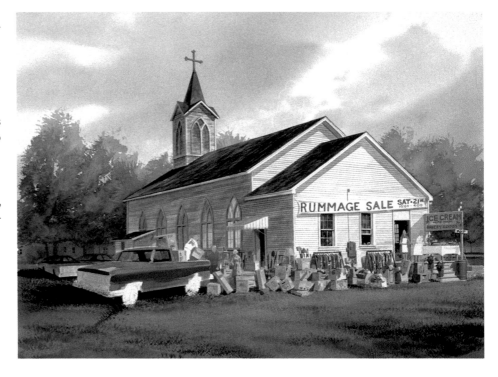

at right

STEP 7

Figures and Vehicles

Add the figures and vehicles last. Since they are the center of interest, use a strong pattern of colors and contrasts. Minimize in value and color the figures to the right so they won't compete with their counterparts on the left. The brightest area of the pickup truck points toward the center of interest, and the front grill is darker and more subtle.

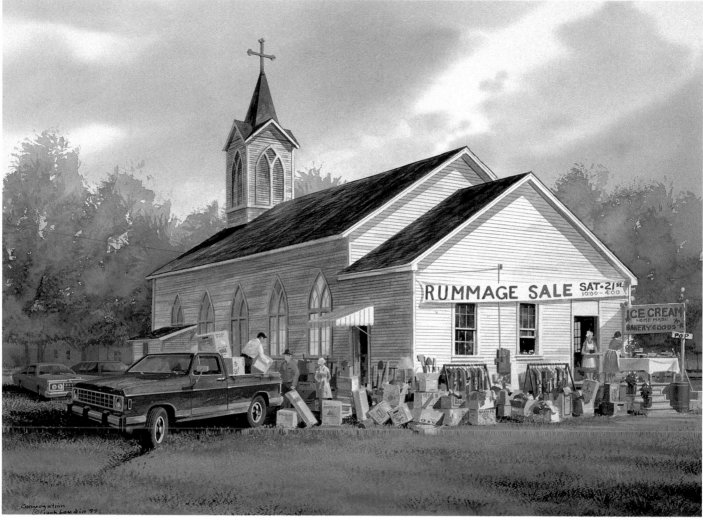

CONGREGATION
16" × 22" (40.6cm × 55.9cm)

"The coming together of dear hearts and gentle people for a social event of any kind, inside or outside of the church, encourages the commingling of parishioners and the wider community. When this congregation includes donated clothing, collectables and confectionaries for the benefit of the belfry, life is good."

People and Animal Tips

PUT THE SPARK OF LIFE IN YOUR PAINTING

There will naturally be some sort of life in your compositions of a hometown scene. Use your camera with a zoom lens to candidly capture the characters of your town. Keep people unaware that they are being observed. Approach your subjects in a generic way—this is not portraiture. Look for interesting people, shapes and gestures to embellish your illustrations.

Keep the human element to a minimum so it doesn't compete with the center of interest. I like to keep my life forms—people, pets, chickens and so on—looking or moving into the composition. Use them as supporting actors to play up the center of interest.

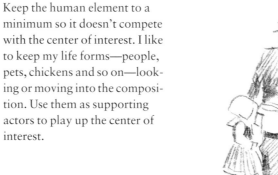

Use animals to bring movement and life into a painting. Include plenty of pictures of animals and fowl in your reference collection. I keep all of my people and animal sketches on tracing paper and file them for future use. Dogs are good to use because they're everywhere in small towns—or any town for that matter. Cats prowl in alleys and out-of-the-way places, so you have to look for them. Sometimes an animal can be the whole story with the rest of the composition as a backdrop.

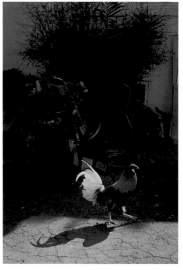

Vehicle Tips

CARS AND TRUCKS

Towns are full of vehicles of all sorts, so use them to help tell your story. A fancy car in a humble setting is an eye-catcher. I have a large reference collection of vehicles and other intriguing mechanicals on 35mm slides. (All taken while standing straight up to maintain the horizon line, of course!)

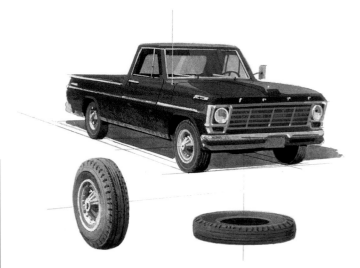

Use a Shortcut

To incorporate a vehicle into a composition, you can project the slide onto tracing paper and copy the basic proportions right onto your sketch. Take any shortcut to get to the painting.

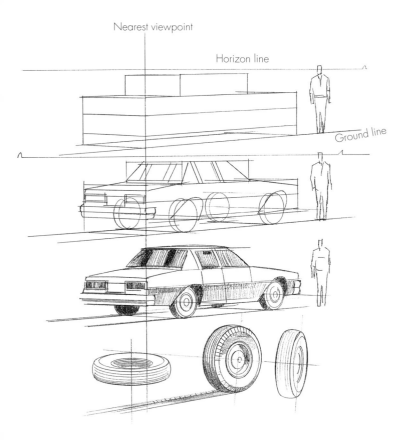

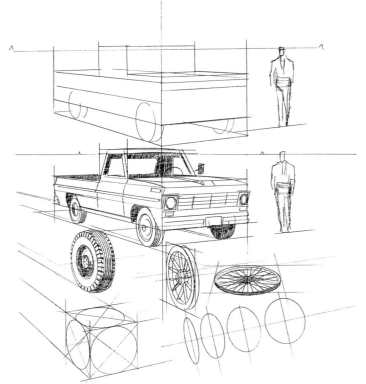

Build a vehicle inside a basic box with perspective lines to keep the horizon line and scale true. Observe and learn some simple car shapes.

Pickup trucks are great characters for hometown illustrations. Learn simple proportions and study wheel and tire shapes. Ellipse guides are indispensable tools for rendering good vehicles. Ellipses are simply circles in perspective and will fit into a square perspective. A basic set of ellipse guides helps keep your drawings clean and crisp and makes your paintings ring true.

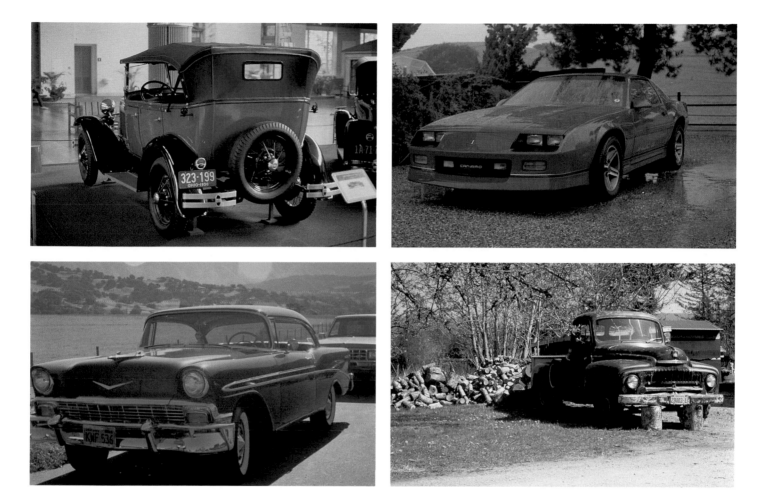

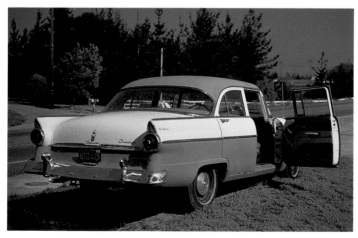

Take Your Own Photos

Don't paint from someone else's photographs. When an idea or inspiration comes to me, I take the photo with the painting in mind—it affects the way I frame a photograph. Back in the studio, I'm able to resurrect the idea I had when I took the shot.

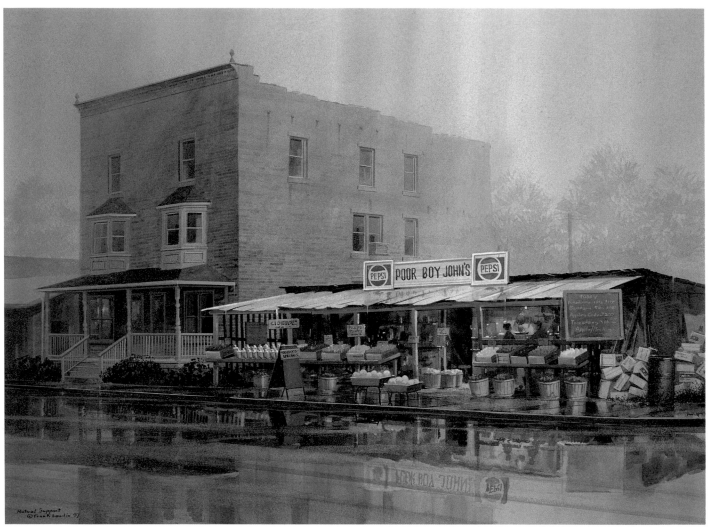

MUTUAL SUPPORT
18" × 26" (45.7cm × 66cm)

Chapter 4

Paint a Rainy Hometown Story

I've always loved rainy days when everything is shiny, contrasts are pronounced and distances are blurred and mysterious. As a boy, I loved to build dams and dikes and to race stick boats in the gutter. I remember listening to spatter on the window as I snuggled in some warm, dry hideaway.

Rain makes brightly clothed people scurry into hot-colored storefronts; it makes the lights of ebony vehicles reflect as bright streaks and shimmers. It's a whole new world to see out there.

In this chapter, we'll take a perfectly dry day and, with some clever brushwork, we'll rain all over it.

Rainy Day Subjects

Look for a composition with a flat area in the foreground for reflections, plus interesting subjects to reflect. A successful rainy day painting has a warm, bright reflected center of interest to contrast against the cool rain hues. Include a few background trees, hills or buildings to suggest a misty, moody midspace behind the center of interest.

Being out on a rainy day with a sketchbook is a tough operation. To scout for a subject, a camera and creative eye are more practical.

These three studies contain nice flat, open foregrounds, dominating architectural shapes and the potential for spots of bright color.

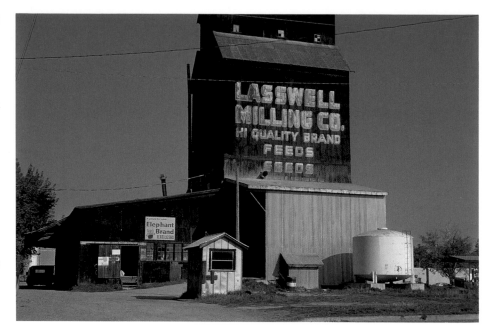

This mill and feed store in Idaho has wonderful architectural shapes. Imagine the rain coming down out of a darkening sky with the upper parts of the building fading into the weather. In my thumbnail sketch, I move the red truck forward at the left, add people at the doorway and some lighted windows. This would be fun to paint because all of the elements would make fine reflections in the foreground with large darks punctuated by streaks and spots of hot lights.

Work Small and Loose
Remember to keep your pencil strokes light and loose in your initial thumbnail. Move intuitively across the paper. Working small and loose allows the ideas to come quickly and helps keep you from getting caught in the details.

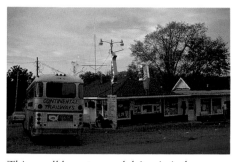

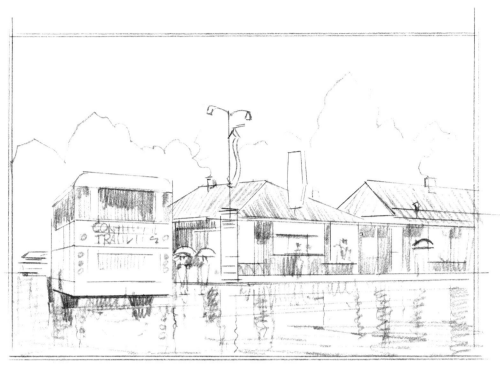

This small bus stop and drive-in is down Arkansas way, early on a September morning. There are lots of lights and lighted signs to work with. It's easy to imagine the lights in the windows reflecting onto the wet foreground. The red taillights on the bus would also cast great reflections. To get a dawn feeling with rain coming down, the sky would need to be a bit darker than in the photograph. I did paint one version of this scene (see *Morning Star*, pages 2 and 3). This time, the story I like shows several people with umbrellas approaching the front of the bus.

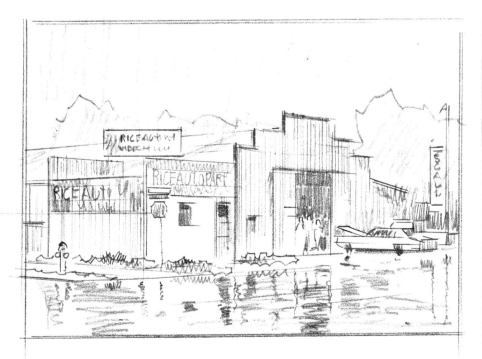

I have to admit that I don't remember where this location is, but look at the great architectural shapes that could be reflected into the foreground. I give the man at the door some pals and open the hood of the car to suggest that they've been working and have been interrupted by the change of weather. A light glowing from inside the large open door will add some hot spots. Imagine all of those reflections into the wet foreground broken up by random tufts of weeds.

Steps to Paint Mutual Support

STEP 1

Use liquid frisket to mask out the fruit and vegetable areas in the front of the market. Use Scotch Magic Tape to mask out two windows on the porch of the boardinghouse and to mask where the figures will be silhouetted against the warm interior light in the market.

Using a mix of Payne's Gray, Prussian Blue and a touch of Raw Sienna to get a gray-blue-green hue, wash over the entire board with large, vertical strokes. This simulates streaks of rain over the whole painting. If you slant the rain, all strokes should slant the same way. Make strokes lighter over the center of interest, going darker toward the right and left.

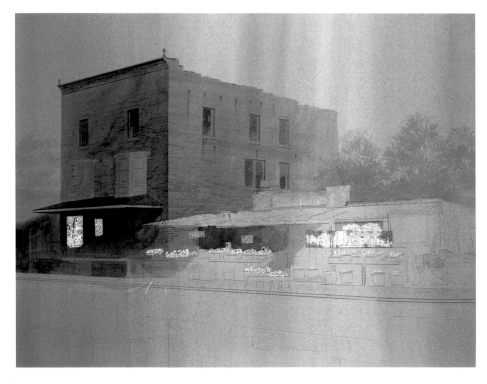

STEP 2

When the first wash is dry, mask the metal roof, which reflects the sky, and the Pepsi sign, which needs to stay light. Also tape out the inner edge of the sidewalk where the reflections begin so you can focus on the market.

We want a misty monochromatic background that counters the reflections and the foreground brights of the market, so work right to left using the same color mix as in the sky. Subtly indicate background trees with a fan brush. Now change to a flat brush and carry the same wash across the boardinghouse, around the corner (go darker and warmer as you approach the front), out to the background structures on the edge of the painting and finish with a faint suggestion of trees to the left of the building.

Next, wash the entire front of the boardinghouse, including the porch and roofs, with the same paint mix. This time, move lighter to darker from the upper left to the lower right, creating a strong contrast at the corner.

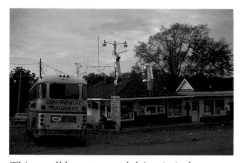

This small bus stop and drive-in is down Arkansas way, early on a September morning. There are lots of lights and lighted signs to work with. It's easy to imagine the lights in the windows reflecting onto the wet foreground. The red taillights on the bus would also cast great reflections. To get a dawn feeling with rain coming down, the sky would need to be a bit darker than in the photograph. I did paint one version of this scene (see *Morning Star*, pages 2 and 3). This time, the story I like shows several people with umbrellas approaching the front of the bus.

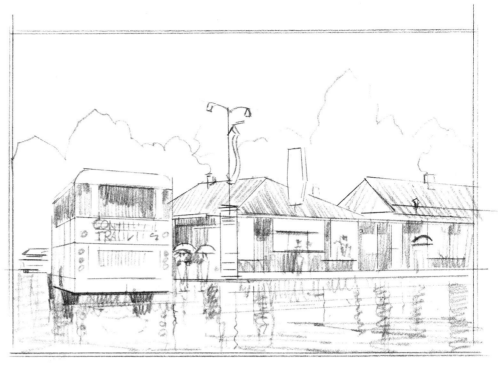

I have to admit that I don't remember where this location is, but look at the great architectural shapes that could be reflected into the foreground. I give the man at the door some pals and open the hood of the car to suggest that they've been working and have been interrupted by the change of weather. A light glowing from inside the large open door will add some hot spots. Imagine all of those reflections into the wet foreground broken up by random tufts of weeds.

Begin With a Sketch

The slide used for this demonstration shows a simple neighborhood market on the downside of town. The proximity of the big brick building got me thinking that somehow Poor Boy John's might be linked with it. The market's name also intrigued me—why "Poor Boy"?—and set my imagination running. By the time I got to the thumbnail for this painting, I had a fully developed background story.

COLOR STUDY

The sky sets the mood on a rainy, overcast day. The general light source is from directly above but is not strong. Cast shadows are undefined and soft. Puddles and reflections become major elements. Running gutters and downspouts add motion and twinkle.

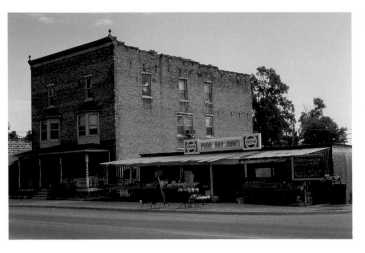

It was a misty September day in Illinois devoid of any activity—empty street, empty market, empty porch. Perhaps the name, Poor Boy John's, first attracted me, but then the composition caught my eye and I knew I could paint it just as it was (adding my little story, of course).

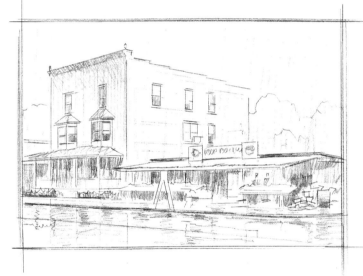

Thumbnail for **Mutual Support**
The long run of pavement in the foreground is perfect for lots of reflections. I add glowing lights and a touch of humanity within the market for a hot spot and center of interest, countering the large, dark area of the rooming house on the left. The reflections will be important in this painting and should be planned and painted carefully.

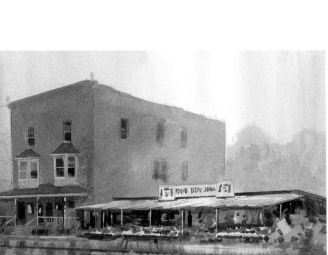

Color Study for **Mutual Support**
A background wash of Prussian Blue and Raw Sienna with a touch of Payne's Gray sets a cool, misty mood.

Compassion and Warmth

Treat all of your subjects with compassion and warmth. Paint a rusty old manure spreader as a monument to the work it's done over the years. An old store covered with tasteless signs can become a beautiful work of art dedicated to enterprise. If the human element is less than heroic at first glance, tell the story so well that the viewer becomes instant friends with the person in the painting.

Establish Perspective

EXTENDED VANISHING POINTS

When establishing perspective control for a large composition, or sometimes for an unusually small drawing, some of the vanishing points often fall off the edge of the drawing table. Usually I can keep one point on the table and the other can be extended by using a 1″×2″ (2.5cm × 5.1cm) board with a good-sized nail protruding from one end. The board is clamped to the table with a C-clamp and angled to line up with the perspective lines in the drawing. The nail represents the vanishing point.

LONG STRAIGHTEDGE

These far-flung vanishing points require the use of a long straightedge. I have a draftsman's six-foot (1.8m) edge, but a clean length of aluminum extrusion works just as well.

The long straightedge can be fastened to the nail at the vanishing point with a looped rubber band. This keeps it from shifting while you work.

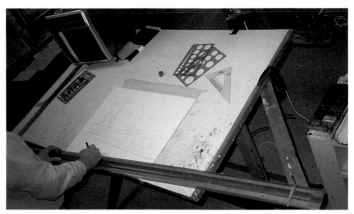

Here I am at my drawing table with my six-foot (1.8m) straightedge rigged to accommodate the extended vanishing point in *Mutual Support*. Note the C-clamp screwed to the upper right-hand edge of the drawing board, and the long nail indicating the vanishing point.

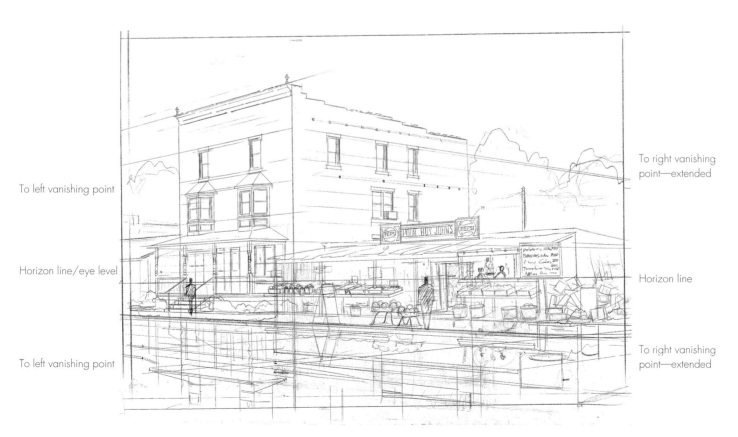

To left vanishing point

Horizon line/eye level

To left vanishing point

To right vanishing point—extended

Horizon line

To right vanishing point—extended

Working Drawing for Mutual Support
In this composition, the perspective drawing offers a particular challenge. The extended vanishing points are way off the page, and it's necessary to use them in order to accurately line up the drawing.

Reflection Tips

I recall from my ancient adventures in art school that there is some mechanical method of plotting reflections, but I say go with whatever looks right. Reflections in a painting are intriguing to the viewer as well as a challenge to the artist, so use whatever it takes to achieve your end. There are a few things you need to think about. If you don't have a photo reference and attempt to plot your own reflections, remember:

1. On a horizontal surface, they are upside down and lean in the same direction as the objects they reflect.
2. Colors and values can be exactly the same or wildly different.
3. A reflection is not necessarily a mirror image, so don't just take an object and flop it.
4. Reflections often catch the undersides of objects, so they can reflect things not seen at eye level.
5. Reflections should always be slightly exaggerated versions of their physical counterparts.

Warm-up to Reflections

If you're insecure about reflections, try this warm-up exercise before committing to your final painting.

1. Stop and practice after you've completed the top part of your painting and before painting the reflections.
2. Cut a piece of board or paper to fit exactly over the reflection area.
3. Draw in your reflection plan and position the board over your painting. Secure it.
4. Paint in the reflections as if they were the real thing.

This test run will help gauge the wetness of your paper and paints, practice lifting off, give you a chance to experiment with lightness and darkness of colors, and give you confidence in approaching reflections.

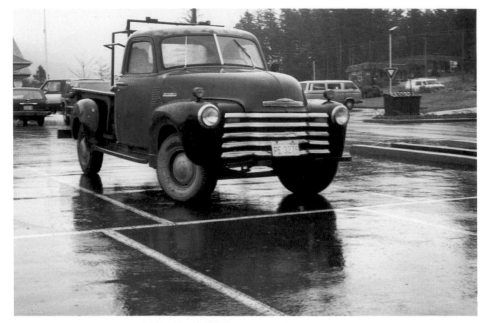

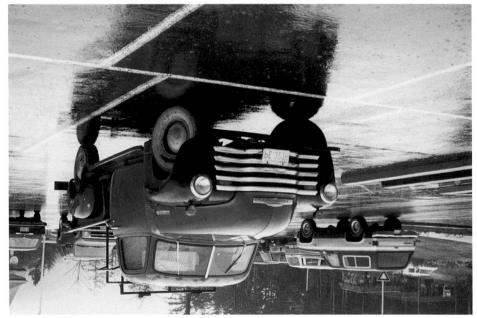

Here is an example of reflections and how they differ from the thing they are reflecting. Notice that when the image is turned upside down, we get a completely different view of the same truck. When a picture is inverted, the eye level shifts along with the horizon line even though it's viewed from exactly the same spot. Imagine standing on your head six feet (1.8m) underground and looking up at the truck. This is what the reflection shows us.

Reflection Plan for Mutual Support

I n *Mutual Support*, the area of reflection covers the entire foreground so that all of the elements above it will be reflected. The market, rooming house, sky and trees—draw everything into the foreground upside down while maintaining the established horizon line and eye level. Objects and shapes that are unseen because of the sight angle, such as the undersides of the porch and market roofs, are revealed in the reflections.

You can turn your layout upside down to draw in reflections if you want to be that detailed. I usually draw just enough to suggest the shapes of objects in the reflecting areas, which to me is more interesting and moody than being too accurate.

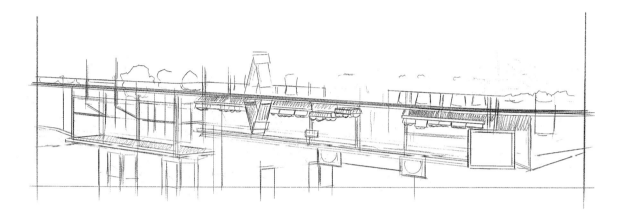

Full-Sized Reflection Plan for Mutual Support
It's a good idea to draw out a detailed reflection plan that delineates where all of the mirror images and reflections will go. Be sure to keep the reflection outlines true to the perspective lines, just as you would with the rest of the painting.

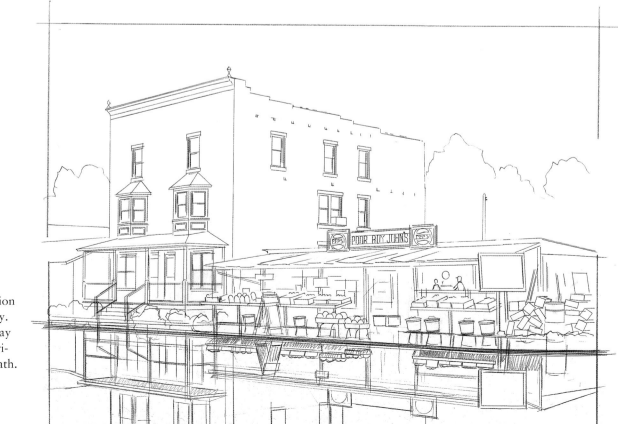

Final full-sized drawing that includes the reflection plan as an overlay. Line up the overlay with the long horizontal lines beneath.

Steps to Paint Mutual Support

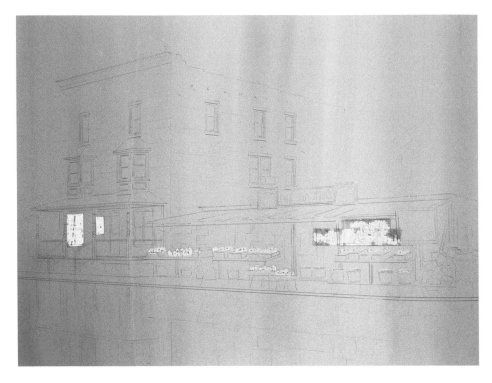

STEP 1

Use liquid frisket to mask out the fruit and vegetable areas in the front of the market. Use Scotch Magic Tape to mask out two windows on the porch of the boardinghouse and to mask where the figures will be silhouetted against the warm interior light in the market.

Using a mix of Payne's Gray, Prussian Blue and a touch of Raw Sienna to get a gray-blue-green hue, wash over the entire board with large, vertical strokes. This simulates streaks of rain over the whole painting. If you slant the rain, all strokes should slant the same way. Make strokes lighter over the center of interest, going darker toward the right and left.

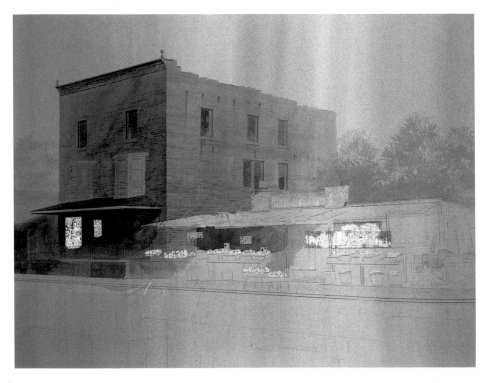

STEP 2

When the first wash is dry, mask the metal roof, which reflects the sky, and the Pepsi sign, which needs to stay light. Also tape out the inner edge of the sidewalk where the reflections begin so you can focus on the market.

We want a misty monochromatic background that counters the reflections and the foreground brights of the market, so work right to left using the same color mix as in the sky. Subtly indicate background trees with a fan brush. Now change to a flat brush and carry the same wash across the boardinghouse, around the corner (go darker and warmer as you approach the front), out to the background structures on the edge of the painting and finish with a faint suggestion of trees to the left of the building.

Next, wash the entire front of the boardinghouse, including the porch and roofs, with the same paint mix. This time, move lighter to darker from the upper left to the lower right, creating a strong contrast at the corner.

STEP 3

Allow this to dry and then use French Ultramarine Blue and Burnt Sienna to create colorful darks that bring out the warmth of the windows and make them look inviting.

Use the perspective guidelines and bridge to stripe in indications of brick on the building—just enough to say "brick wall." Then detail the window trims and woodwork on the front porch with Opaque White.

Now remove all the liquid frisket and tape, except along the reflection edge, and begin to work on the market area. We want a warm interior, framed by dark wood and echoed by the lighted window in the boardinghouse and the cool, bright colors on the produce out front. There's a lot going on here, so try to make each area pleasing while keeping in mind the value and color study. It's trial, error and adjustment. Work around the entire area until it looks good to your eye.

Paint the Pepsi sign and the metal roof, adding some rusty streaks and texture, and sharpening the whites with Opaque White.

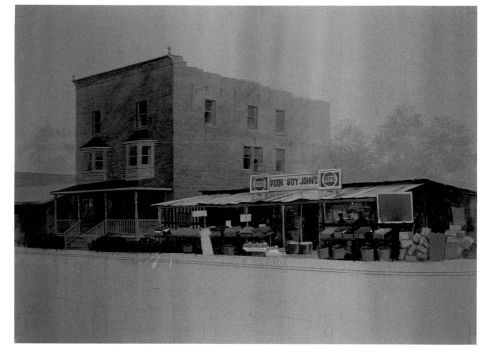

Bushel Baskets, Stacked Boxes and Crates

Use ellipses to keep baskets uniform and truly round. Select the correct ellipse to fit the scale, and draw in a row of baskets with ease. A similar tip works for boxes and crates, especially when they're not the center of interest. Cut a rectanglular-shaped stencil or template to the correct scale, and use it to randomly draw in crates with each shape the same size. I arbitrarily select a convenient vanishing point to help me arrange the tumble of rectangles in perspective and give some depth to the stack. It's fast. Try it!

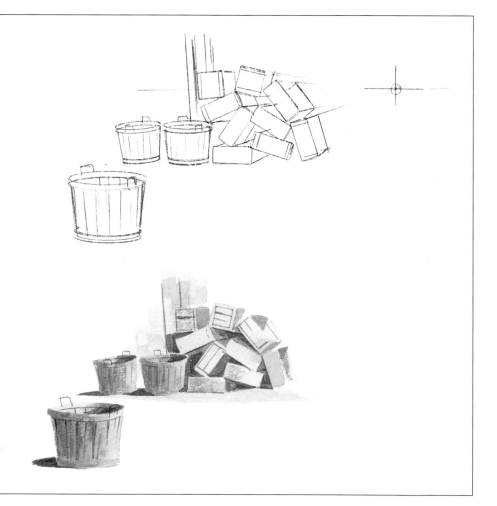

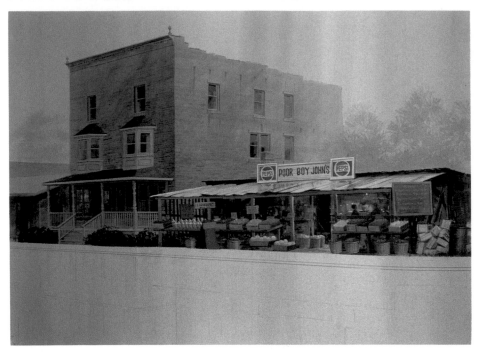

STEP 4

When everything down to the Scotch Magic
Tape at the upper edge of the reflection area
is finished, pull up the tape. Position a fresh
strip of tape across the bottom of the com-
pleted painted area in order to freely work on
the reflections.

 Thoroughly wet down the entire reflected
area, then quickly paint in shapes wet-into-
wet using vertical strokes, and keeping
roughly within the penciled reflection plan.
This is a tricky moment and takes some prac-
tice, but it's fun with exciting results.

 When dry, go back and brush on horizon-
tal streaks of clear water. Moving in the same
direction, follow quickly with a clean, dry
paper towel to lift out lighter areas. This indi-
cates drier patches in the street.

 Following the direction of the street and
perspective guidelines, lightly drybrush in
some hints of tire tracks to give the street
more definition. Use a slightly darker color
than the roadbed for the tracks.

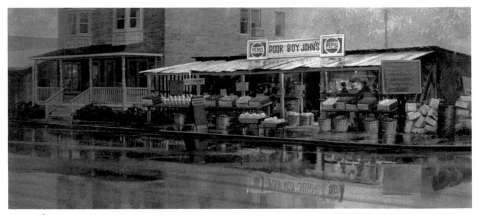

Detail

at right

STEP 5

When dry, remove the last strip of Scotch
Magic Tape and get ready to make rain. Mix
up some of the original sky color with a touch
of Opaque White. Splatter on rainy texture
using a toothbrush and your thumb, work-
ing background to foreground. Background
rain is darker than the sky, and foreground
rain is lighter. Keep the raindrops in scale.
You don't want blobs in the sky.

 Be subtle and practice with some test
splatters on scrap board before trying this on
a newly completed masterpiece. Keep a dry
paper towel handy to lift unwanted or mis-
placed splotches. Don't overdo it, or you will
have snow. (That's coming in the next
chapter!)

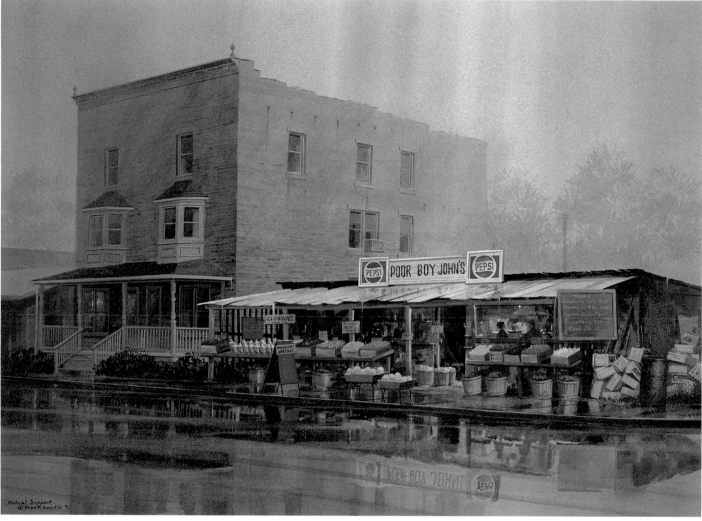

MUTUAL SUPPORT
18" × 26" (45.7cm × 66cm)

"They measured time in berries to cherries and carrots to cabbages, as the early victory garden grew and the tomato stand expanded beyond supplying the best boarding table in town. Now they labor with love through the seasons, full and fallow, in mutual support."

Other Hometown Views

QUAPAW BATHS

QUAPAW BATHHOUSE
Pen and Ink, 30" × 40" (76.2cm × 101.6cm)

Gary Simmons

The Quapaw Bathhouse is on Hot Spring National Park's Bathhouse Row and is renowned for its tiled dome. Gary chose this angle in order to include the most distinctive part of the bathhouse while still placing it "on the row" of bathhouses. The magnolias and lush vegetation are a large part of the intimate feeling one gets while walking in front of the bathhouses. The nostalgia of the period is captured in part by the street lamps, so he wanted to make one of them a prominent element in the composition. The frame includes architectural artifacts from the building and magnolia blossoms, both chosen to enhance the feeling of details even though the building is in the distance. The sense of light was very important to the drawing, particularly as it highlights the bushes and sidewalk.

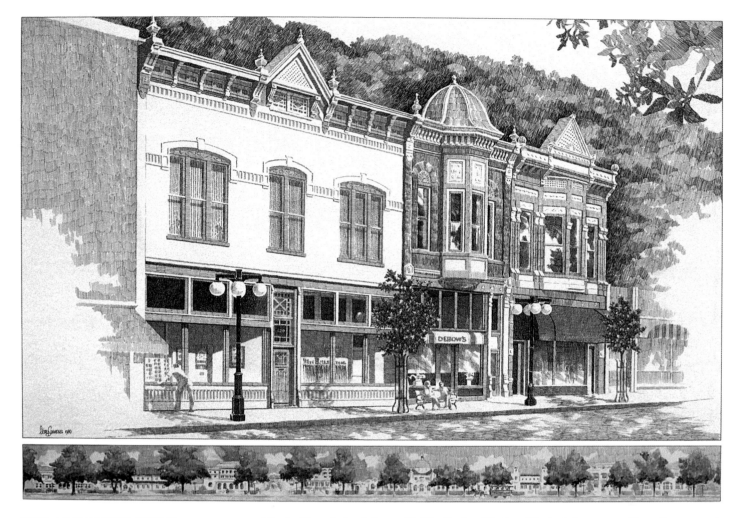

THE ART FOUNDATION
Pen and Watercolor, 30" × 40"
(76.2cm × 101.6cm)

Gary Simmons

The Art Foundation is located in Hot Springs National Park, Arkansas, and is really a portrait of a city block with the Art Foundation at its center. The challenge was to include three major buildings and still create a center of interest. The small frieze at the bottom of the drawing is a color rendering of the bathhouses on Bathhouse Row located immediately across the street from the Art Foundation. Gary chose this frieze in order to create a sense of place for the drawing. By including Bathhouse Row, the drawing is more marketable as a print because it suggests the city's historic district and makes the drawing's interest more public and less of a personal statement for specific property owners. Gary also purposively de-emphasized the building on the left, which is a bank and offers no historic interest.

Steps to Paint Another Hometown View

The watercolor called *Atop Vroman's Nose* by Elizabeth Apgar-Smith was sold at its first showing, and was chosen for the sole image on the Wilber National Bank's 1996 calendar. She received a fee for the use of her painting as well as great exposure, which brought requests for other paintings of the vista. She decided to do another version using pastel over watercolor to enhance the rich variety of textures in the subject.

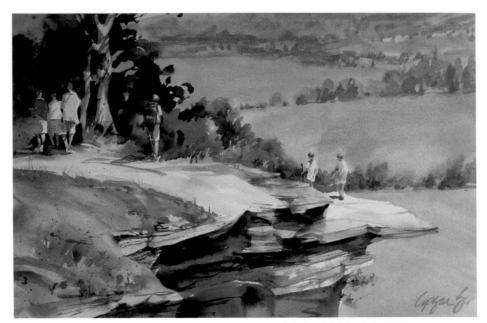

ATOP VROMAN'S NOSE
Watercolor, 15" × 22" (38.1cm × 55.9cm)

Elizabeth Apgar-Smith

STEP 1

Pencil Sketch and Layout

The sketch for the original watercolor was made on site. Betsy carries a 2B pencil and an Aquabee sketchbook wherever she goes. She draws a box to establish the format of her composition and then roughs in the basic values in large shapes, adding enough detail to have a good reference from which to paint back in the studio. She also makes color notes and jots down emotional impressions in the margins.

All her sketches are sprayed with a fixative so they can be used again and again. Her sketches are invaluable reference material. She sometimes works a group of figures from one sketch into another.

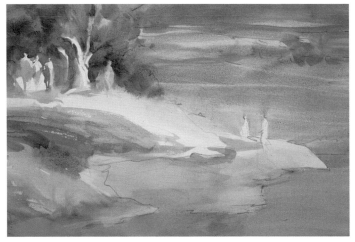

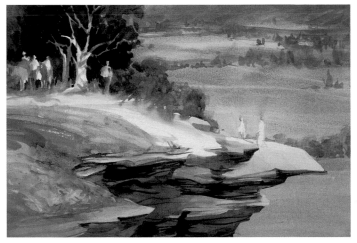

STEP 2

First Watercolor Pass

Following her value sketch, Betsy lays down washes of cool, soft color for the distant valley in the background and warmer, more intense color in the foreground, leaving light-struck areas white or very light. Because her plan is to work pastel over the watercolor, saving whites isn't as crucial as it is in watercolor, but it saves work later.

STEP 3

Second Watercolor Pass

The second layer of watercolor establishes the darker areas and defines shapes such as the figures and rock areas a little more. The color intensity and dark values are exaggerated since the painting will be finished with pastel, which will soften and neutralize.

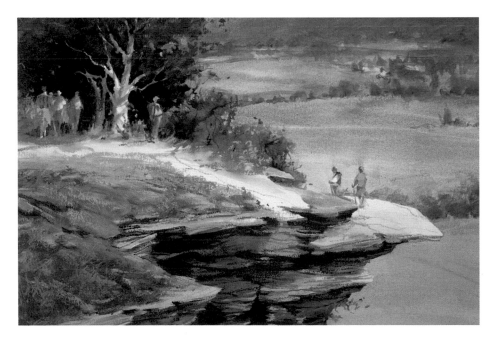

STEP 4

Pastel Finish

To finish the painting, Betsy uses pastels that are close in value to the watercolor under-painting. The craggy texture of the rock cliff is brought out with horizontal strokes and areas of foliage are softened with curved strokes. She finishes with a few details and shadows on the figures and tree trunk. Complementary colors are used to neutralize some areas, while analogous colors intensify the color in other areas to move the viewer's eye through the painting.

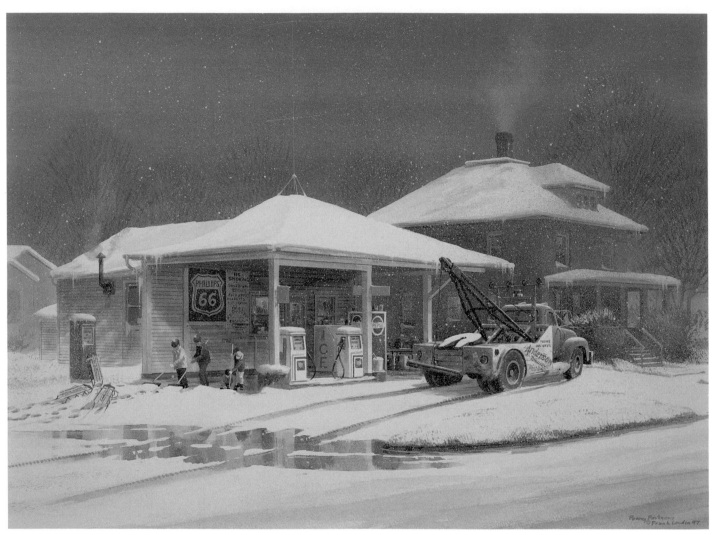

PENNY PARTNERS

18" × 26" (45.7cm × 66cm)

Chapter 5

Paint a Snowy Hometown Story

I t's snowing!" The morning you wake up to find three inches of wet white stuff transforming the outside world, your aesthetic indicator takes a big swing to the white side.

When it snows, everything changes. Even on an overcast day, the light is intense. The most delicate shadows are deep blues and greens. Negative space suddenly defines the dominant features in a snowy landscape. There are few hard edges or familiar shapes.

Whenever I contemplate a snowy painting, even in midsummer, I recall some special winter adventure of my own. I still get goose bumps when I remember taking down the old Flexible Flyer from the garage rafters, sanding its runners and then rubbing them with candle stubs to make my sled the fastest on Shinn's Hill. What a thrill!

Get excited about painting snow by drawing on your own memories. Take walks in the snow whenever you can and collect reference photos. Even if it never snows where you live or you've never seen snow, you can still paint a snowy picture. There are scads of visual references in our culture, from Currier & Ives Christmas cards to magazine features about ski resorts.

As we did with rain in the last chapter, here we'll take a familiar hometown landmark and cover it with snow, picking up snowy principles and techniques along the way.

Use Overlays to Fine-Tune

Work up a rough drawing to position the architectural elements and get a general idea where everything else goes.

Using overlays, I fine-tune the position of the kids, sleds and tow truck. Then I place a clean sheet of tracing paper over everything and do a final drawing. It's important to know where the large white snow shapes will be in the composition, so I make a snow overlay and a track and puddle overlay as well.

Truck Overlay

This is a favorite truck and has appeared in several of my paintings. I rough it into the drawing to establish location and size. On a separate piece of tracing paper, I project the reference slide to the proper size for the composition and copy the rough proportions. Then I tape this drawing to the working drawing and establish alternate and separate vanishing points for the truck. Check scale against the horizon line, which is already in place.

Children Overlay

Experiment with different poses for the children through a series of quick figure studies. Then I incorporate the one I want into the composition with an overlay. Kids dressed in bulky, lumpy winter togs are easy to imagine and fun to paint. They often wear bright and unusual color combinations. Winter mail-order catalogs are great references for kid's clothing and even some good poses.

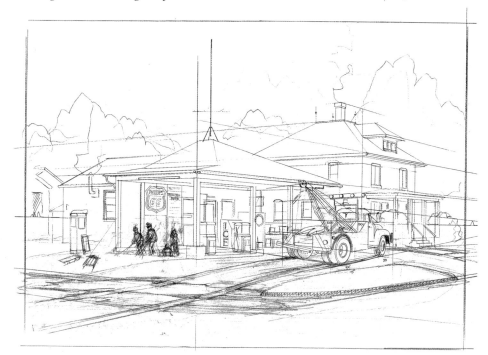

Rough Working Drawing for Penny Partners

Most of my thinking and planning is represented by light pencil lines and scribbles. I'm more creative when I don't worry about erasing. Freely experiment with composition—shift borders, change sizes and proportions, add and delete. It's easier to change things at this stage than later.

Snow Overlay

The snow overlay shows how four inches of white stuff can alter a subject. Plan for rounded edges and obscure lines. For example, when the drawing is transferred to watercolor board, only the outlines of the snow-covered roof will be traced, not the roof itself.

Puddle Overlay

On a piece of tracing paper, plan the foreground puddle so it lays flat in a logical low place in the gutter. Arrange the tire tracks to tell of the recent arrival of the truck. The puddle's purpose is to add interest to the foreground, so position it to pick up reflections that enhance the subject matter.

Final full-sized drawing for *Penny Partners* incorporating the snow, kids, truck and puddle overlays.

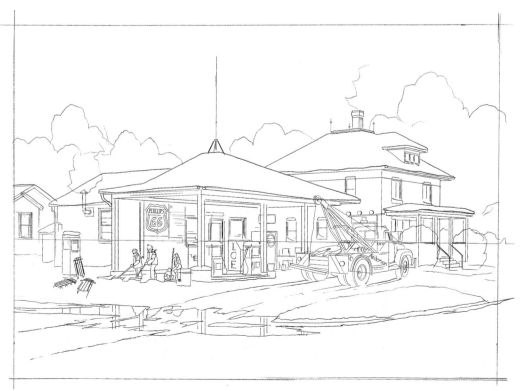

A Snowy Color Study

Once the drawing is finalized, it's on to the color study. I mask all of the snowy areas with liquid frisket to save the whites and wash in the sky with a mix of Payne's Gray and a touch of Alizarin Crimson. I carry the wash into the buildings, adding a little more Alizarin Crimson to suggest reddish bricks, and continue this warm, rosy gray throughout the buildings and the puddle.

The gas pumps and kid's clothing are clear, primary brights to contrast with the pure white of the snow and the background's pastel softness. The interior-lit windows are warm orange and yellow.

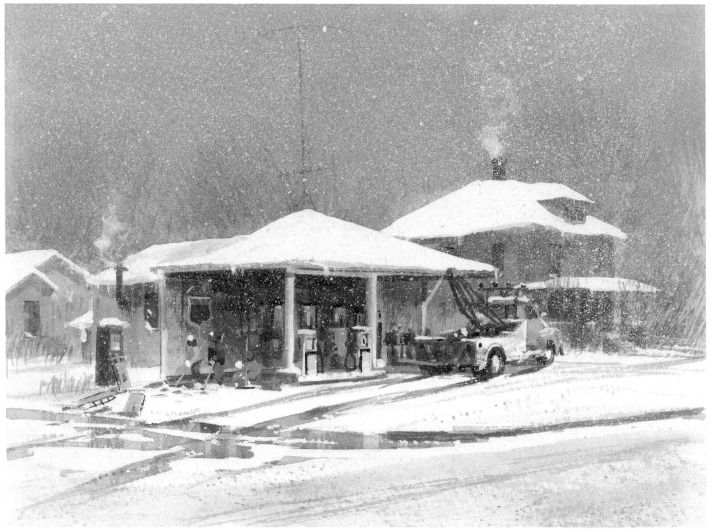

I like to keep my snowy scenes on the warm side of the palette because I think it makes them more inviting. If you really want to get chilly, try mixing a cool blue such as Prussian Blue with Payne's Gray.

Steps to Paint Penny Partners

Mask Snow
Follow the snow plan and mask out the snow areas of the roofs and other key spots with liquid frisket.

STEP 2

Wash in Sky
With large strokes, wash in the background sky using Payne's Gray with a touch of Alizarin Crimson. I want the background dark enough to offset the white of the snow, and later, the splattering of snowflakes. When the sky wash is dry, indicate the tops of leafless trees with the tip of your fan brush.

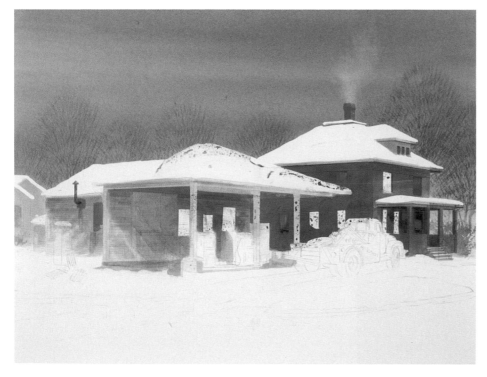

STEP 3

Buildings
Mask out the posts in front of the station and the top edges of the truck with liquid frisket. With Scotch Magic Tape, mask some windows so you can light them with a warm glow later. For the whitish walls of the building, paint the initial washes with a lighter version of the sky color and paint a more crimson, darker version of the sky color for the red brick house. Now go over the buildings with a series of washes until you achieve the proper values. Add some texture to show aged siding on the station. With a Pink Pearl eraser, gently rub out some of the sky pigment to indicate wispy smoke from the chimney.

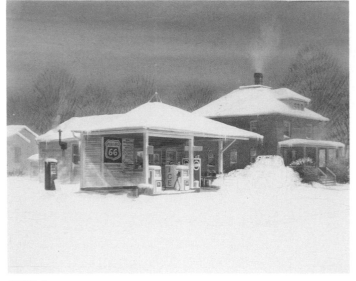

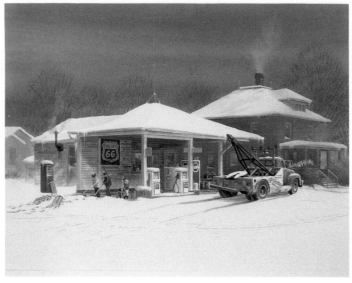

STEP 4

Details for the Buildings

Remove the liquid frisket from the snow shapes, the Scotch Magic Tape from the windows and complete the details of the buildings, including the warm, interior-lit windows and the gas pumps in front of the station. Add icicles and shading to indicate depth to the snow on the roofs. Fan brush snow texture to the tops of the bushes in front of the house. Splatter a fine haze of snowflakes over the house to create distance.

STEP 5

Truck and Children

After removing all of the remaining liquid frisket, work on the tow truck and kids. Keep the truck relatively pale in values and colors. Don't compete with the strong brights of the children and station front as the center of interest.

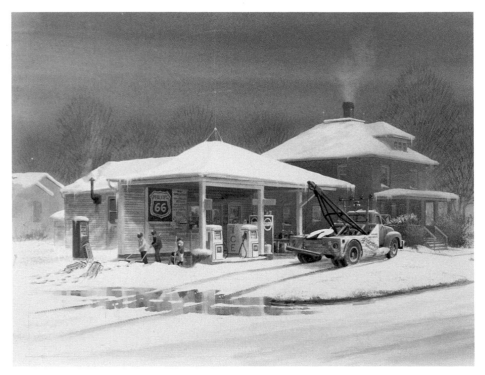

STEP 6

Puddle

Use liquid frisket to mask the edges of the puddle and the white areas that you want to retain. Paint in the water and reflections, working wet-into-wet as the wash dries. When dry, remove the frisket and complete the puddle by lifting out some lost edges and adding a few darker spots to indicate snow depth. I decide to add some track-like strokes to the lower right foreground for textural interest and to make the snow lie down flatter.

at right

STEP 7

When the painting is finished to your satisfaction and is completely dry, splatter on the final layers of snowflakes. Take care not to splatter too heavily over the center of interest. Work from the background to the foreground with the tinier splats being the farthest away.

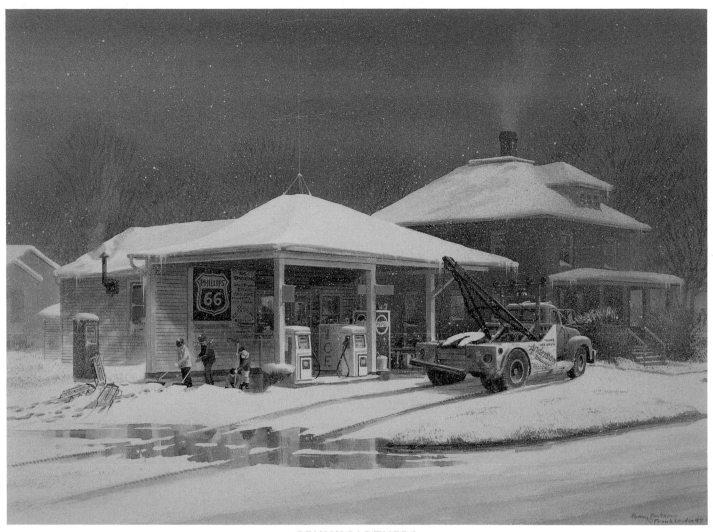

PENNY PARTNERS
18"×26" (45.7cm×66cm)

"The big fluffy flakes floated out of the Saturday morning sky like popcorn spilling from a box, covering everything almost faster than they could shovel. If they shoveled till 12:45 at the agreed-upon wage, there would be just enough pennies to take them to the 1:00 matinee, popcorn, jawbreakers and Ne-Hi Orange pops."

Snowy Tips

TECHNIQUES FOR PAINTING SNOWY SCENES

Here are a few exercises and techniques for painting effects common to snowy scenes. Practice before jumping into your actual painting.

ICICLES, ROOFS AND EAVES

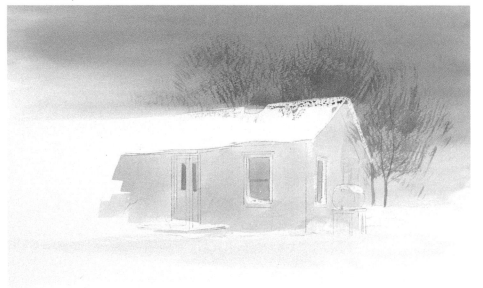

First . . .

Plan where the snow will accumulate in the composition—mainly on the roof, where snow drapes over eaves and drips into icicles. Be sure to include the lower corners of windows and other places where snow piles up in drifts and makes icicles.

Mask out the white areas with liquid frisket, keeping soft, rounded edges. Also mask out all of the window areas down to the snowy ledges because in order to paint warm, glowing windows, you need to start from white paper. Then paint in the sky, background trees and walls of the house.

Remove the frisket from the windows and paint in the first warm window wash.

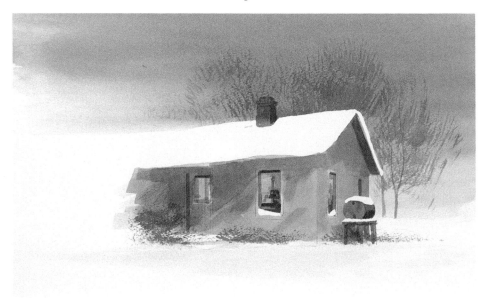

Then . . .

Remove all of the remaining liquid frisket and paint in the chimney, fuel tank and door jamb. Add foreground vegetation, texture to the walls and interior window detail.

Finally . . .

Keeping the same monotone gray of the sky and building, give the snow on the roof depth with a light wash for the chimney shadow. Add a hint of shadow where the snow is deep enough to curl around the eaves. Paint in icicles in a few spots with a light touch, using Opaque White or gray. To get a wisp of smoke coming from the chimney, erase a loose shape in the background wash with a Pink Pearl eraser. When dry, splatter Opaque White over the whole painting using a toothbrush and your thumb. The falling snow should be denser in the background than in the foreground to give depth to the atmosphere, but don't overdo it.

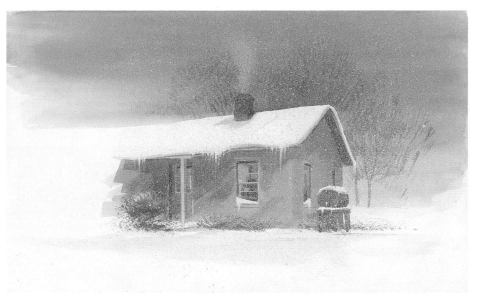

WINTER TREES

Trees Set a Wintry Mood

Most deciduous trees are bare in winter, and I like to use their leafless silhouettes to help set a wintry mood. First, paint in the trunk and main branches. Then, following the proportions and shape suggested by the trunk, drybrush in small branches with your fan brush, adding additional limbs with a small brush where needed. Branches generally radiate from the main trunk and limbs in a balanced pattern.

More Snowy Tips

LIGHTS AND SNOW

I had all of these snow and light ideas planned and did the painting shown here so I could try them. It was fun.

To get this glowing effect, use the mask and splatter method. After completing the background cityscape, I splattered Opaque White and a yellowish white around the billboard area. Once dry, I laid down pieces of scrap mat board to form the shape of the directional glow from the overhead lights in the center right. With the rest of the painting masked with mat board, I liberally splattered Opaque White and a little yellow onto the cone-shaped area.

To make the Christmas lights glow, I saved the bright white of the Crescent board by masking out the lightbulb shapes with liquid frisket before applying the first wash. When ready to paint the lights, I cut a round hole about the size of the glow I wanted in a piece of scrap mat board for a mask. I removed the frisket and, holding the mask off of the surface, splattered a fine mist of paint through the hole. Holding the mask off of the surface produced a diffused look, and the pure pigment covered the spot where the white paper was saved and showed brighter than the surrounding glow.

Practice these tricks on scrap board—not on a painting you have been working on for a week!—until you get the knack.

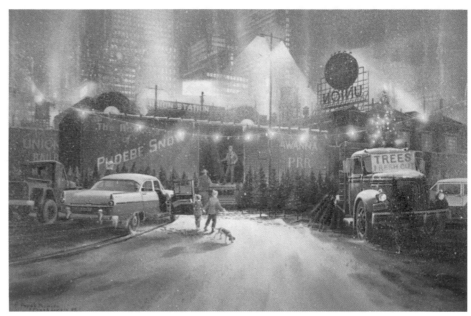

PAPA'S PROMISE
16" × 24" (40.6cm × 61cm)

"Papa promised us a special tree, but even his eyes grew brighter in the snowy fairyland of lights as Christmas drifted across the city with a whisper and looked down upon the freight yard where the spirit gathered."

Toothbrush Splatter

Artists have all sorts of techniques for creating a splatter effect. I like the one-handed method so I can see where the splatter is going. I dip an old toothbrush into my medium, hold it in my fist and flick my thumbnail across the bristles. Mix a little Opaque White in to get the right consistency. A wet mix produces looser and larger splatters. Be sure the splatter pattern coincides with the direction of the texture plan. Rain and snow are usually vertical while gravel and dirt should follow your perspective lines.

A wonderful corner for snow overhangs and icicles

Wispy smoke made by lightly rasing with a Pink Pearl eraser

Snow buildup and drift on porch roof

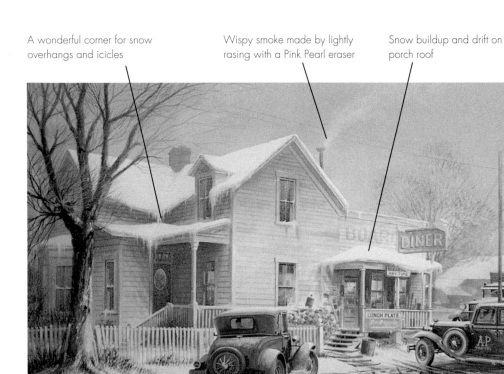

THE BREAKFAST CLUB
16" × 24" (40.6cm × 61cm)

"*Even on days off, the good ol' boys were drawn to the diner to swap lies and sip coffee. Only nonmembers referred to them as 'The Breakfast Club,' for anything resembling officialdom would bring only a chorus of snorts and guffaws.*"

Winter trees show bare branches. Background objects are lightly splattered with small snowflakes to create distance.

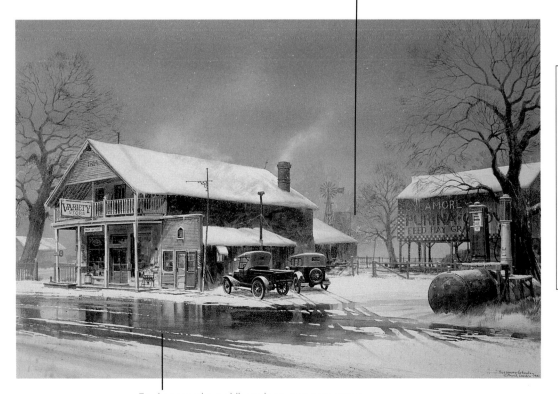

SYCAMORE SATURDAY
18" × 28" (45.7cm × 71.1cm)

"*Saturday morning offered a variety of entertainment as tall tales rattled the mirrors in the barber shop and down-home gossip gathered around the stove at the Variety Store next door.*"

Tracks across the puddles indicate recent movement of the autos and lead us into the painting

Other Hometown Views

HOLLY HOUSE
Pen and Ink, 20" × 24" (50.8cm × 61cm)

Gary Simmons

The Holly House is a Victorian home in Hot Springs National Park, Arkansas. The building was a store specializing in Christmas gifts and ornamentation. This made it important to choose an angle for the composition that featured the Holly House sign. An angle from the corner might have obscured the sign, making it hard to recognize, so Gary chose a head-on view. He also had to consider an angle that allowed him to get far enough from the house to see the whole structure. Since it sits on a corner lot, the view he chose showed most of the building as well as the sign.

CABIN AND CHICKADEE
Pen and Ink, 16" × 20" (40.6cm × 50.8cm)

Gary Simmons

This was a commissioned piece by the owners of the cabin, who were particularly enamored with it as their hideaway. They happened to be avid bird-watchers and mentioned in passing that there was a nest of chickadees that they always looked forward to in the spring. The drawing of the cabin alone was a little austere because of the small subject in a large field of view. The photo Gary was provided wasn't large and the pen-and-ink medium didn't lend itself to the color embellishments you can give to winter scenes with paint. The chickadee was included to make the overall picture more intimate, to make the composition more interesting and to give the viewer a spot where there was more detail and a greater sense of being in the picture. Gary didn't want the trees and the cast shadows in the snow to overwhelm the picture, so he was selective about the amount of detail he used.

LIMITED EDITION PRINTS

After selling her work for some time, Elizabeth Apgar-Smith noticed two things: A number of people wanted paintings that were sold, and the price of her originals rose to a point that was out of range for many people. She decided to expand her marketability by publishing a limited edition print. She was fortunate to have a good friend in the graphic design business to advise her. Here she shares her experience with us.

1. PICK A PAINTING I chose a painting with local appeal. *Holiday Lights* had already been exhibited, won awards in area shows and received many compliments. My only hesitation was that it was definitely a seasonal subject, but I decided to risk it. In the past, our town promotional society staked small evergreen trees on each property along Main Street. The property owners decorated them and Schoharie, New York, glimmered with brightly lit trees. This festive tradition is no longer in practice, so I knew the print would at least have a lot of local interest.

2. GET A GOOD TRANSPARENCY I take my own slides to send to galleries and competitions, but my graphic designer friend recommended I have a professional photographer shoot a 4″ × 5″ (10.2cm × 12.7cm) transparency. He made five slightly different exposures and from these I chose the transparency truest in color to my original.

3. SETTLE ON A PRINT SIZE I decided on an image size for the print. My original painting was 18″ × 24″ (45.7cm × 61cm), but I was advised to go with a slightly smaller standard size print, 16″ × 20″ (40.6cm × 50.8cm), for easier framing and selling. This also keeps the original unique.

4. DETERMINE THE NUMBER OF PRINTS IN THE RUN I decided on an edition of five hundred prints. It was enough to get a good return on my investment, and anything over that seemed too large for a "limited edition" run.

5. SELECT PAPER STOCK My first choice of paper, Mohawk Superfine—an excellent acid-free paper, had to be changed after the first proof showed it was not quite right for my painting.

6. DECIDE ON A LAYOUT I wanted my title, *Holiday Lights*, on the print, so I chose a typestyle and size to be centered at the bottom of the image. My designer produced a layout mechanical with the title positioned under a box the size of the image. A mechanical is a working board made to guide the printer when making reproductions. It consists of all components—in this case, camera-ready type and the position of the illustration—pasted up at the correct size.

7. FIND A PRINTER My friend got estimates from several reputable printing firms that do high-quality four-color printing. The quotes were close in price, so her experience in the field helped a lot. We chose a printing house based on their track record with quality reproduction of original art and the ability to do in-house color separations, which saved time and money. I sent the transparency and camera-ready layout to the printer for color separation.

8. CHECK PROOFS AND MAKE CORRECTIONS The first proof, called a chromalin, was a little too red and needed color adjustment. The second was better, but the paper was too absorbent for the rich color in my image, which resulted in a dull-looking print. For sharper reproduction, the printer suggested a coated stock to prevent color bleeding into the paper.

9. ROLL THE PRESSES For the final print run of five hundred, we traveled to the print shop to check press proofs on-site. It's worth it to personally fine-tune the color. The room-sized presses are amazing, and I learned that the color can be adjusted in specific areas by simply touching a button. The printer had me sign the final proof when I was satisfied. I left with a few press sheets and waited three days for the prints to be delivered.

10. MARKET THE PRINTS Each print must be signed and given an edition number: 1/500, 2/500 and so on. I saved the first twenty for family and friends and began to market the rest. After talking with artists in my area who had published prints and checking the prices of comparable prints in galleries and magazines, I decided on a price of sixty-five dollars. Then, I took a framed print and several unframed prints to galleries that carried prints, beginning with galleries that had already handled my work. I also contacted an art agent who had been recommended to me. For about a year, she exposed my print to the mass market at big city art expos and sent promotional packets about the print to galleries across the country. I used the image on a Christmas card that I sent to my mailing list and received quite a few orders at my studio. However, most of my sales occurred through the galleries I contacted. Within the first three to four months after printing, I'd recovered my initial investment of $1,400. Even now, several years later, the prints are still in demand and represent pure profit.

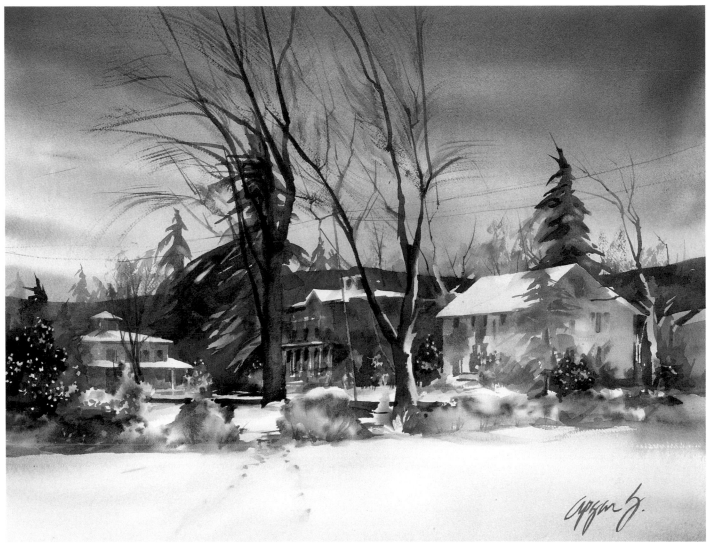

HOLIDAY LIGHTS
Watercolor, 18"×24" (45.7cm×61cm)

Elizabeth Apgar-Smith

METAMORPHOSIS ON MAIN
18"×26" (45.7cm×66cm)

Chapter 6

Paint Your Hometown Railroad Station

These quaint reminders of bygone days linger on in most towns. Once the center of town activity, with much coming and going, some stations have now become the center of preservation controversy. Many have disappeared, some have been misused, but others have been saved, refurbished and become commercial jewels in revitalized downtowns.

I feel fortunate that I witnessed American railroads at their peak. I remember lying in bed on rainy nights with the sound of the night trains coming from exciting distant cities and chugging off into the darkness. The most exciting trains were the ones that hurried through town with a great rumble, leaving a pall of cinders, a secret message for the station master and the bundle of evening papers.

I've done several paintings of my favorite stations, but fewer and fewer people can identify with such historic sentimentality. Those days are gone forever, but today there are plenty of examples of new life being breathed into these venerable buildings.

In this chapter, we'll renew a neglected town landmark with a contemporary spin out of our own imaginations.

Select the Subject

I find that railroad stations lend themselves to all sorts of story lines.

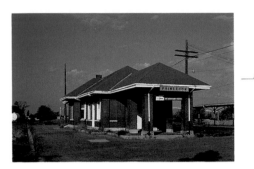

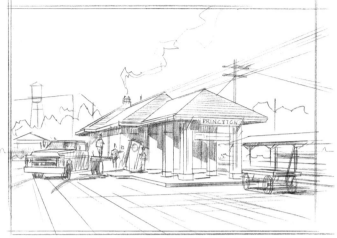

This station in Princeton, Illinois, seemed to be in pretty good shape and was being used at the time I took the photo. The Amtrak sign bodes well for the future. For my thumbnail, I add men contemplating loading a large item onto a truck, and some smoke from the chimney for warmth.

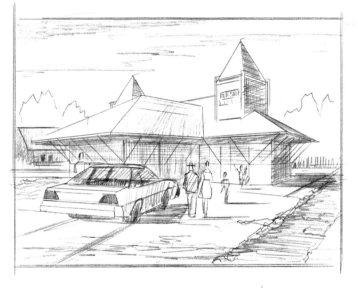

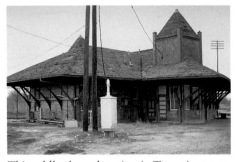

This oddly shaped station in Texas is at a crossing of two lines. It seems the powers that be could not decide which side got more traffic, resulting in no obvious front or back to the structure. My story line brings a young family escorted by an older gentleman back to where he was station master. Maybe they will be able to save the dear old station for a new enterprise.

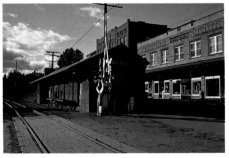

This station in Pennsboro, West Virginia, is dear to my heart. As a small boy in the thirties, I stood on this spot and experienced the thrill of main line B&O railroading. Drawing from my memory, I add a boy on his red Hawthorne bicycle to offset the architectural elements of the structures. This could be me.

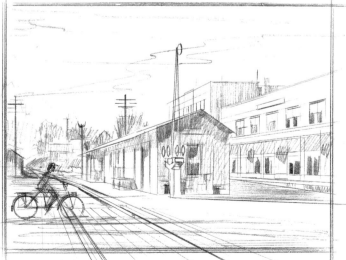

Develop the Story and Begin With a Sketch

Imagine that this station is in Anytown, U.S.A., where time and the interstate have left it and its contemporaries on the backstreet of economics. Recently, with a burst of civic pride and some aesthetic wisdom, the town has been reborn. Old Main is a planted mall with pedestrian walkways leading to colorful new shops and restaurants in those wonderful brick buildings.

The old train depot is happily caught up in the spirit of renewal and is transformed into a bright, cheerful flower shop, truly a *Metamorphosis on Main.*

This wonderfully preserved station is in the Strasburg Railroad Park in East Strasburg, Pennsylvania. Because of it's charm and condition, I can easily see this building put to a fresh, contemporary use.

***Thumbnail for* Metamorphosis on Main**
The venerable old station is transformed into a snappy flower shop spread out beneath a sunny canopy. The entrepreneurs go about the morning's business while receiving a delivery from the nursery tradesman.

Establish Perspective

Since there are no people in the reference photo, it's up to us to determine the placement and size of the figures added to the composition.

As discussed before, I take all of my reference photos from a standing position, therefore, my eye level and the horizon line are roughly six feet (1.8m) off the ground.

Wherever a figure is located, if it's standing on the same level as the viewer, the top of the head is always at the eye level line or close to it. Allowances are made, of course, for figures of varying heights. Once the position of the head is established, place the feet on the corresponding ground level and draw in the figure proportionately.

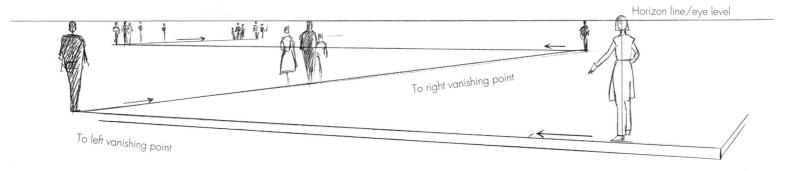

Remember the six-foot man walking a zigzag path in chapter one? This partial perspective overlay for *Metamorphosis on Main* shows how human scale can be carried throughout a composition by the use of perspective and vanishing points.

Refine the Composition With Overlays

I carefully placed elements in the distant and middle backgrounds (buildings, water tower, vehicles) to balance the composition, keeping the flowers and shopkeepers at the center of interest and preventing the architectural strength of the station's roof from dominating.

Something tall is needed in the left foreground to offset the water tank in the right distance. I found this semaphore in one of my railroading books. Using it as a decorative lamppost carries through on the underlying railroad theme.

As usual, I use overlays to position elements on my rough working drawing. Here, I use them for the signal/lamppost and the foreground people and truck.

Signal/lamppost overlay

Human figures and truck overlay

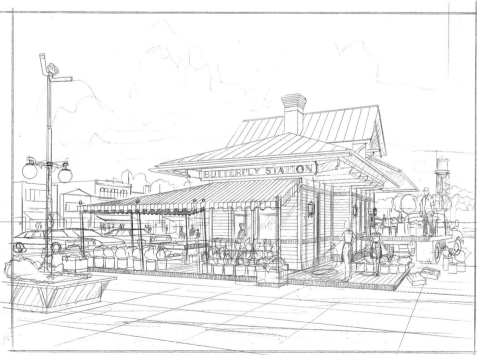

Final Full-Sized Drawing
Note that I've had ample opportunity to use my ellipse guides. When a composition calls for pots, buckets, cans or anything cylindrical, ellipse guides are a handy tool. Select one appropriate in size and degree. The guides help maintain consistency with ease. Don't get too carried away, though, because painting a whole bunch of pots or cans is tedious.

The Color Study

Even though the subject building is rather worn, fresh paint and clean windows give it new life. I want to maintain that freshness throughout the painting. Color choices and utilizing a crisp, clean technique will help do that.

The tone is set by a spring-flavored sky, bright and clear colors, clean shapes and two energetic shopkeepers. The foreground flowers are the brightest spot, and the band of colorful blossoms and green pots carries across the composition.

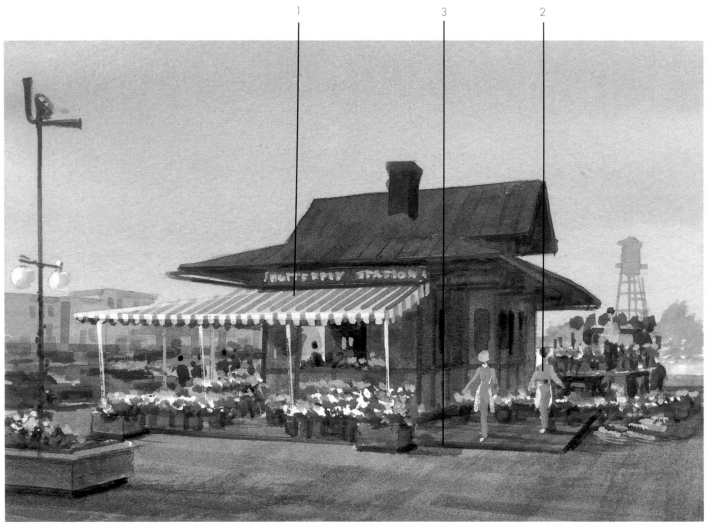

Use the Color Study as a Tool
A good reason to bother with painting a color study is to try out your first color choices and value impulses. After reflecting on this color study, I can immediately see three changes I want to make in the final painting:

1. The blue awning stripes tend to go more with the sky than with the building, creating a hole in the architecture. So I'll make them a cool green to echo the greens of the pots and foliage, which ties the awning to the center of interest.
2. I decide to individualize the clothing of the shopkeepers instead of having them in uniform. This seems more realistic and eliminates the problem of a too strong band of lavender moving through the center of the composition.
3. The curb strip at the edge of the brick pavers would provide contrast and draw the eye into the center of interest more effectively if it was light instead of dark.

Steps to Paint Metamorphosis on Main

STEP 1

Use liquid frisket to mask out the awning shape, areas for flowers, lamppost globes and three principal human figures. Then wash in the sky and background using broad strokes of Prussian Blue with a touch of Winsor Violet, lighter at the horizon and darker up above. Paint the background street and skyline using the same mix of sky colors with a touch of Burnt Sienna for warmth. Limit the color and contrast in the background to keep the sense of distance.

Continue on the background, adding architectural detail, cars and a trickle of small figures across the street.

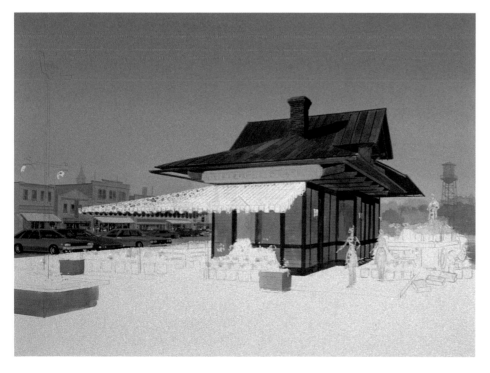

STEP 2

Use a wash of Cadmium Red, Burnt Sienna and a touch of French Ultramarine Blue to dull the roof and chimney of the station down. It takes two washes for the intensity I want, and then I work on details of shadows and line, using my bridge to strip in brick and roofing definition. This is a metal roof, so the seams follow the pitch of the roof. Wash in the station walls and the undersides of the eaves with Raw Sienna mixed with a touch of Burnt Sienna. Paint around the windows. Don't bother to mask them since the windows will be dark with dark trim.

For the shadow, rafter and fascia detail beneath the eaves, go across the color wheel to French Ultramarine Blue which, when combined with Raw Sienna, produces a cool, receding shadowy gray.

Use Burnt Sienna and French Ultramarine Blue to create a dark, rich brown and paint in the siding and trim work on the building walls using straight, clean edges.

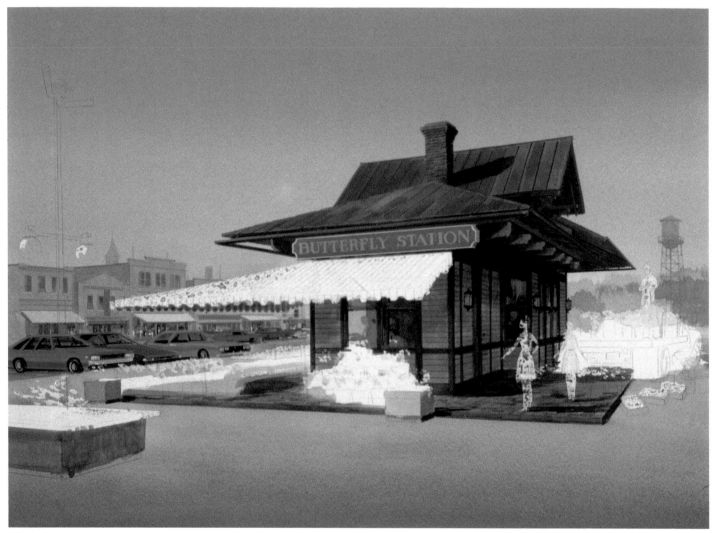

STEP 3

Finish the building details including the windows, carriage lamps and sign, then move on to the brick pavers. Lay down a wash of Cadmium Red with a touch of French Ultramarine Blue, and when that's dry, go back and define the bricks. Keep the lines in perspective and scale.

When the pavers are done, paint in long cast shadows where appropriate to indicate early morning sunlight.

Cover the large white area in the foreground with a thin wash of Burnt Sienna and French Ultramarine Blue, going more toward the blue where you want it grayer.

Painting on Commission

From time to time, you may be commissioned to do a painting. Try to be businesslike even though your ego is inflamed. You and your client should fully understand and agree upon what is expected of both parties. Be particularly clear about the price and delivery time. I present a color study or sketch and collect a 50 percent down payment before proceeding to the final painting.

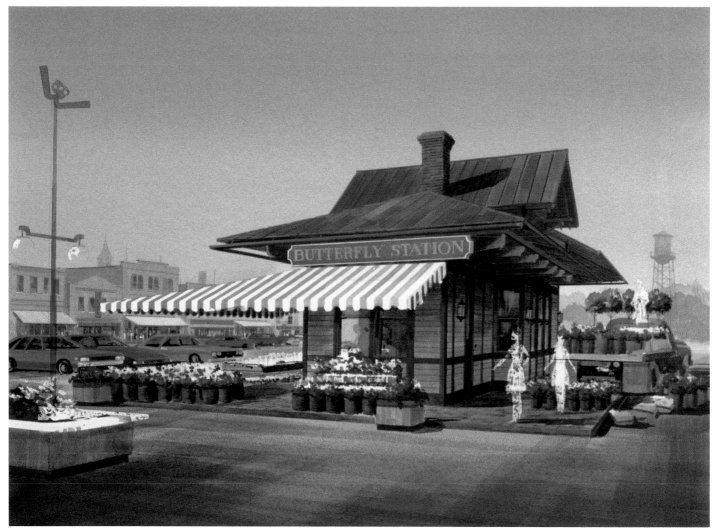

STEP 4

Allow the foreground to dry and stroke in overlapping glazes, carefully following the perspective lines so the shading lies flat and no accidental shapes suddenly stick up. In this manner, work from light to dark, accentuating the center of interest with a lighter spot and deepening the cast shadows. When you're satisfied with the washes, splatter some texture on to suggest gravel. Paint in the signal/lamppost pole, and then remove the frisket from the awning shape. Paint in the stripes with a cool green mixed from Prussian Blue and Cadmium Yellow. When that's dry, put in the deep shadow line of the far side of the awning in cool blues. Then paint the truck detail and begin to work across the composition, painting the flower pots and foliage. For the pots, I used the same green as I did for the awning but with a bit of French Ultramarine Blue added to darken and dull it down. Alizarin Crimson could be used as well, or any cool, purplish hue across the color wheel from the awning green. The foliage is a greener hue of Prussian Blue and Cadmium Yellow.

Changes Along the Way

Don't be afraid to depart from your original plan as a painting unfolds. My approach may seem organized with sketches, color studies and perspective plans, but certain things simply come to me in the midst of the painting process. It would be dull if we knew exactly how each painting would turn out. For example, far along into painting *Metamorphosis on Main*, I had the brainstorm that "flutterby" is a more lyrical, energized and fun word than "butterfly." Even though I had to redo the lettering, I changed the name of the shop to Flutterby Station.

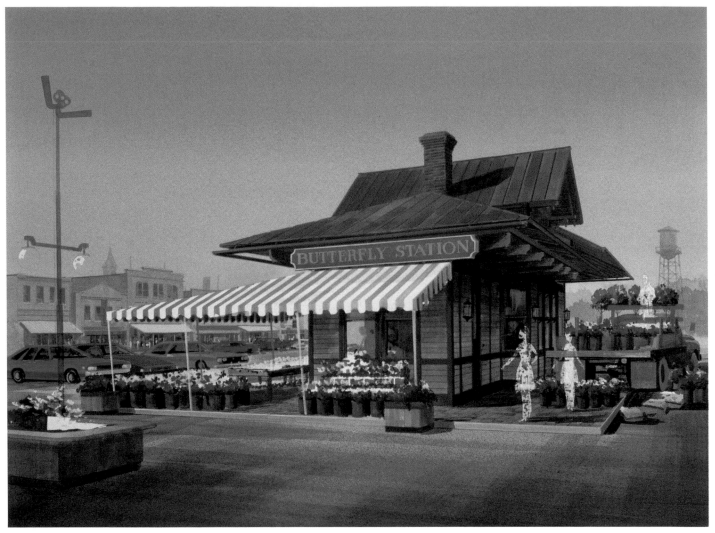

STEP 5

Using Opaque White, paint in the awning poles and the detailing on the lamppost, and lighten the curb edge along the brick pavers to create a stronger contrast at the center of interest.

Now it's a matter of working over everything in the middleground until you're satisfied that it all relates in color and value.

at right

STEP 6

Remove all frisket and paint the flowers with clear, bright colors. I adjusted the values in the sign, making them sharper, which gave me the opportunity to change the name to my late-breaking brainstorm, Flutterby Station. I also dulled down the value of the background awnings across the street, which were suddenly too bright and distracting.

I finished the detail on the signal/lamppost after researching my railroad books to make sure of the correct color placement for the signal position. Note the reflections from the red roof and green plants that follow the curves of the glass globes.

Add a coiled hose, background tools and "garden art" to the walls. Using Opaque White and the same masking technique as demonstrated for a snowy lamplight in chapter five, create a stream of spray from the hose. Paint in the three figures last.

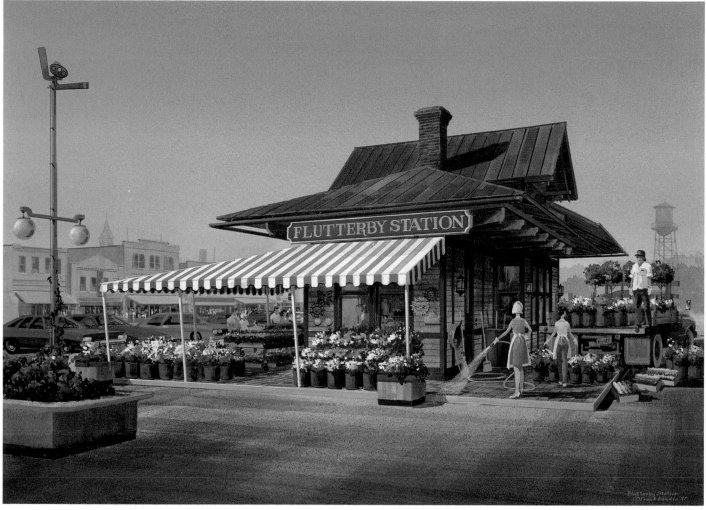

METAMORPHOSIS ON MAIN
18"×26" (45.7cm×66cm)

"These two perky proprietors are symbolic of the revitalization along the abandoned railroad right-of-way in the oldest part of town. Like the mysterious metamorphosis of a beautiful butterfly, this venerable station has burst into glorious bloom again. This time, it is not with the hustle and huffing of the steam age, but with a riot of spring gathered beneath its wings."

Other Hometown Views

This is the Missouri Pacific Depot. The challenge of this drawing is the brick work—suggesting brick texture without really outlining the bricks. The technique Gary used gives the brick a softer and friendlier look than hard-edge brick outlines. This drawing was part of a nostalgia series for Hot Springs National Park that presented areas of the city that its citizens fondly remembered. The depot was chosen as a place that saw the departure and return of three wars. It was converted to a popular restaurant called the Sawmill Depot and included the artifacts of the railroad. The drawing is designed to recall that nostalgia with trains and railroaders.

MISSOURI PACIFIC DEPOT
Pen and Ink, 20" × 24" (50.8cm × 61cm)

Gary Simmons

ROADSIDE BOUNTY
Watercolor, 15"×11" (38.1cm×27.9cm)

Elizabeth Apgar-Smith

READY FOR MARKET
Watercolor, 15"×11" (38.1cm×27.9cm)

Elizabeth Apgar-Smith

FARMSTAND
Watercolor, 7½"×11" (19.1cm×7.9cm)

Elizabeth Apgar-Smith

"When people can place themselves in the setting of a painting," says Betsy, "an emotional bond is frequently formed between the viewer and the work." The Schoharie Valley is well known for it fertile farmland, and these roadside stands dot its landscape and draw patrons from all of the surrounding counties.

Presenting, Promoting and Marketing Your Work

The enthusiasm for observing life's adventures with the idea of capturing an elusive moment or impression can be a consuming pastime. To have an excuse, especially an economic one, to seek out stories through illustrations is one of the rewards of being a creative artist.

Personal satisfaction in your work is great, but when the excitement of creating expands to encompass others, the fulfillment is multiplied. Sharing your artistic achievements reaches its zenith when other people are so touched by your work that they want it for their own. However, your work must be seen in order to be appreciated, and closet creators never get anywhere with the public. It's up to you to let the world know you are an artist.

SIGN YOUR WORK

Artists have different styles of signing their work. In a front corner of my paintings, I put my signature, the title, the copyright © symbol and the year. I stamp the back of the painting with a 2½″ × 3″ (6.4cm × 7.6cm) stamp that reads, "All reproduction rights reserved by Artist." It also has lines for the title, signature and date. If an unscrupulous bootlegger decides to make a killing with Frank Loudin images on coffee mugs and T-shirts, he's been warned.

MATS AND FRAMES

Always have at least a studio mat on anything you show to a prospective client. Frames and mats define and finish a painting and thus become part of the composition, so take care in their selection.

In general, watercolors should be double matted in neutral tones that don't distract from the painting. The eye should go to the colors and values in the painting and not the mat. Likewise with frames. Complicated ornate frames are for mirrors.

Most metal frames are easily scratched and, once damaged, difficult to repair. I use frames that can stand up to repeated packing, shipping, carrying and rehanging. Fortunately, my subject matter is compatible with the look of distressed and weathered molding.

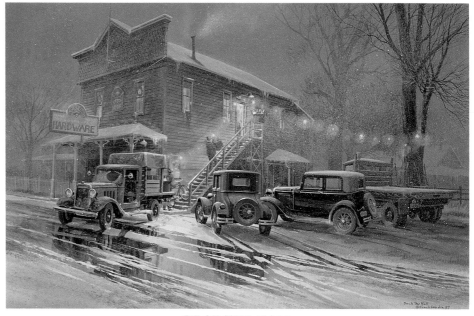

DECK THE HALL
16″ × 24″ (40.6cm × 61cm)

"That was the year that it started to snow just after school on Friday with the Christmas 'Do' at the Lodge Hall that same night. The lights, the truckload of secret red packages, the excited kids, everybody humming and kidding around . . . I mean to tell you!"

Exhibiting Your Paintings

No matter where you live, there are many ways to get your work before the public. These fall into three categories.

GALLERIES AND ART SHOWS

If there's an art gallery in your town, visualize your paintings hanging in it. Approach the gallery owner about showing there.

Business policies at galleries vary, but most sell on a commission basis and want to cultivate long-term relationships with the artists they represent. Sometimes a gallery doesn't suit your work and vice versa, so don't force it.

In many parts of the country, various organizations sponsor art shows that range from county fairs to artists associations to Kiwanis fund-raisers, all of which are excellent ways for a beginning artist to break in. Be on the lookout for notices on bulletin boards and in local papers.

What galleries and shows have in common is that someone other than you underwrites and organizes the exhibit. All you have to do is paint, frame and deliver your masterpiece on time!

THE BOOTH ROUTE: STREET FAIRS, FESTIVALS, PUBLIC EVENTS

Many communities have annual events that extend open invitations to artists and craftspersons. This is an excellent way to build recognition. Some artists follow the events circuit in the summer, traveling from town to town with their displays. Who knows, the Megatawnee Horseradish Jubilee could be your lucky break!

For a fee or a percentage of the sales take, the artist sets up shop in a designated space and handles all the display and selling. You'll probably need to provide vertical walls to display your paintings, especially in open-air settings, and perhaps display racks for unframed work. I have a portable cage made of wire mesh with a back and two side walls that takes up about a 6′ × 8′ (183cm × 244cm) space.

Your work should be tastefully and professionally arranged, with prices and titles prominently displayed. Make up business cards or flyers with your biography, artistic philosophy, available paintings and prices—whatever you think might be of interest—so no one leaves your booth empty-handed. Stay with your work, greet people, engage in conversation, weave the magic.

Make Your Booth Stand Out

I like to define my space with potted geraniums, and I offer hard candy or a bowl of grapes for the visitors. Invite browsers to sign a guest book or raffle off a small painting so you can start a mailing list.

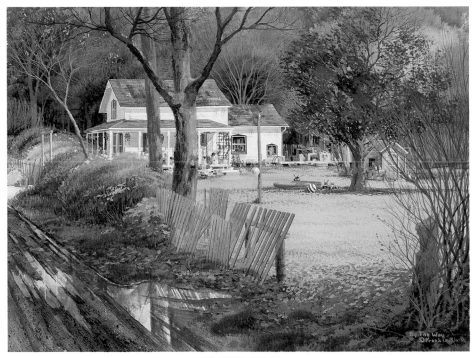

BY THE WAY
12″ × 18″ (30.5cm × 45.7cm)

"By the way to Madrona Point is a place that can only be appreciated if you just stroll along, in no hurry, on a sunny day, which is the only way to travel . . . by the way."

Art in Unexpected Places

Paintings can be effectively marketed in unexpected places. Look around your community with an eye toward possibilities. Are you finding blank clinic and hospital reception walls? Would your painting style complement an antique shop or home garden center?

Make a list of possible venues in your area. Think of public areas and businesses where:
1. People congregate
2. There is adequate wall space and decent light
3. Your subject matter and style are compatible

4. Those in charge are amenable to displaying original art

Restaurants, libraries, banks, Chambers of Commerce, book stores, local newspaper offices, hotel lobbies, gift shops, inns—the list is endless. In my town, for example, a local artist's group has an ongoing rotating show at our medical center. The staff and patients love to be surrounded by this changing display, and the artists actually sell their work from time to time.

Be Proactive

Use your imagination and select a place where your paintings will jump out. Approach the manager or proprietor with a proposal. You may be surprised how willing they are to give it a try. Some may expect a commission, but others will simply be delighted to have their establishments enhanced by your work. Handle sales by having buyers contact you directly or through a cooperative proprietor.

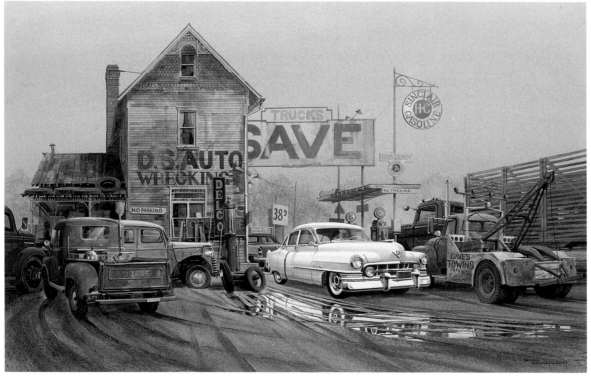

QUEENIE
18" × 28" (45.7cm × 71.1cm)

"Don't you wonder what a nice girl is doing in a place like this? Well, Dave of D.S. Auto, who actually lives upstairs, drives away from this place without a spot of mud or grease on his shoes or hubcaps."

Final Thoughts on Selling

The bottom line concerning sales is that you are your own best promoter. It's up to you to get your name out there.

PROMOTE YOURSELF

There are dozens of ways to keep your name in the public eye.

- If your hometown or neighborhood paper is small enough, it will publish notices of your activities. Provide the editor with press releases and photographs.
- Volunteer to design logos for posters and T-shirts for community events and nonprofit organizations.
- Help design and construct sets for local theater presentations.
- Start an art docent program at the local grade school.
- Paint "on location" where people will see you. This creates an undeniable mystique.
- Open your studio to individual visitors or offer to participate in an artist's studio tour fund-raiser for a local cause.

One last, but very important word on sales: Never forget to express gratitude to those who support your work. Whether your paintings sell through a gallery, a show, a business or your own efforts, always convey your personal thanks with a note.

SPIRIT OF THE PLACE
10″ × 18″ (25.4cm × 45.7cm)

"Our spirits lift and swirl on a May day's breeze that tosses a gaggle of gulls into the sky. Indian Island beckons us to adventure across the bottom of the sea for a rare visit to her enchanted shores."

Guest Artists

ELIZABETH APGAR-SMITH lives in the village of Schoharie, New York, where she maintains a working studio and teaches classes and workshops. A self-described "constantly evolving artist" it is her imagination's take on a subject that Betsy homes in on. Her impressionistic renderings of moments captured mainly in her northern Catskill environs are to her, "visual poems that represent how I see or feel about the world around me."

While an art major at Skidmore College, she saw the possibility of a painting career when commissioned to paint racehorses and show dogs. But after graduating, she worked as an art therapist for three years, then spent ten years raising three boys to school age before circling back to full-time painting.

She is a juried member of the Northeast Watercolor Society, the Central New York Watercolor Society, the Oil Pastel Association of America and other regional art societies. Her paintings have twice won awards in the *Artist's Magazine*, and have won competitions sponsored by Winsor & Newton, Inc., the Salmagundi Club of New York City, the Northeast Watercolor Society, the Oil Pastel Association of America and the Cooperstown National Exhibition. Her paintings have been included in four reference books on technique published by Quarto Publishing Company, London.

She is represented by the Greenhut Gallery in Albany, New York; the Picture Perfect Gallery in Canajoharie, New York; and the Six Day Gallery in North Adams, Massachusetts. Betsy can be contacted at her studio (518-295-7731).

DR. GARY SIMMONS is a nationally recognized artist who resides in Hot Springs, Arkansas, with his wife, June, and daughters, Jamie and Rebecca. Gary began his art career at Southern Illinois University in Carbondale where he was a student in Buckminster Fuller's industrial design program, in zoology, and eventually in English and American literature. He completed his doctorate in education at Indiana University in Bloomington, Indiana.

His art career has centered around pen and ink, which he began as a student science illustrator. He began a freelance illustrator and graphic design career in 1976. Gary's work is recognized for its craftsmanship and mastery of pen technique and drawing skills.

His collectors and clients include such celebrities as authoress Lady Mary Stewart in Scotland, Hall-of-Fame horse trainer Jack Van Berg, Hollywood writers and producers Harry Thomason and Linda Bloodworth, and President Bill Clinton.

In addition to one-man shows, Gary's honors include awards in juried competitions such as the New York Knickerbocker Society's 1992 John J. Karpick Memorial Drawing Award, and selection for *Who's Who in the South and Southwest* as well as nomination for the 1993 *Who's Who in American Art*.

He has lectured and conducted workshops for Koh-I-Noor Rapidograph and wrote the book, *The Technical Pen: Techniques for Artists* (Watson-Guptill, New York). He has also produced an instructional videotape titled, "A Pen-and-Ink Demonstration by Gary Simmons."

In addition to commissioned portraiture and studio work, he currently teaches at Henderson State University in Arkansas. His work is represented by Palmer's Gallery 800 in Hot Springs (501-623-8080). Gary can also be contacted at his studio (501-525-1639).

Index

INDEX